The Art
of Drapery

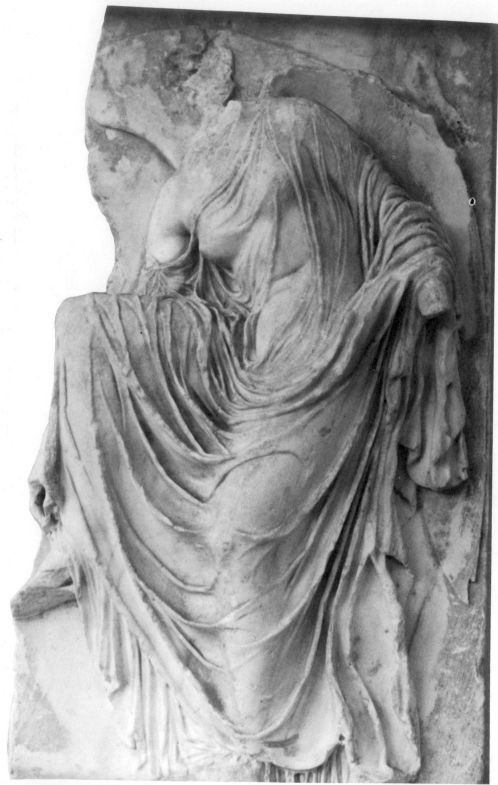

Nike Loosening Her Sandal, from the parapet of the temple of the Acropolis Museum (height: 38.5 cm). Photograph by the author.

The Art of Drapery

STYLES AND TECHNIQUES FOR ARTISTS

Mario Cooper

VAN NOSTRAND REINHOLD COMPANY
New York Cincinnati Toronto London Melbourne

Printed in the United States of America
Designed by Charlotte Staub

Published by Van Nostrand Reinhold Company Inc.
135 West 50th Street
New York, New York 10020

Fleet Publishers
1410 Birchmount Road
Scarborough, Ontario M1P 2E7, Canada

Van Nostrand Reinhold
480 Latrobe Street
Melbourne, Victoria 3000, Australia

Van Nostrand Reinhold Company Limited
Molly Millars Lane
Wokingham, Berkshire, England RG11 2PY

16 15 14 13 12 11 10 9 8 7 6 5 4 3 2 1

Library of Congress Cataloging in Publication Data

Cooper, Mario.
　　The art of drapery.

　　Includes index.
　　1. Drapery in art.　2. Art—Technique.　I. Title.
N8217.D73C66　　1983　　743'.5　　82-19987
ISBN 0-442-21875-3

To Dale,
once again

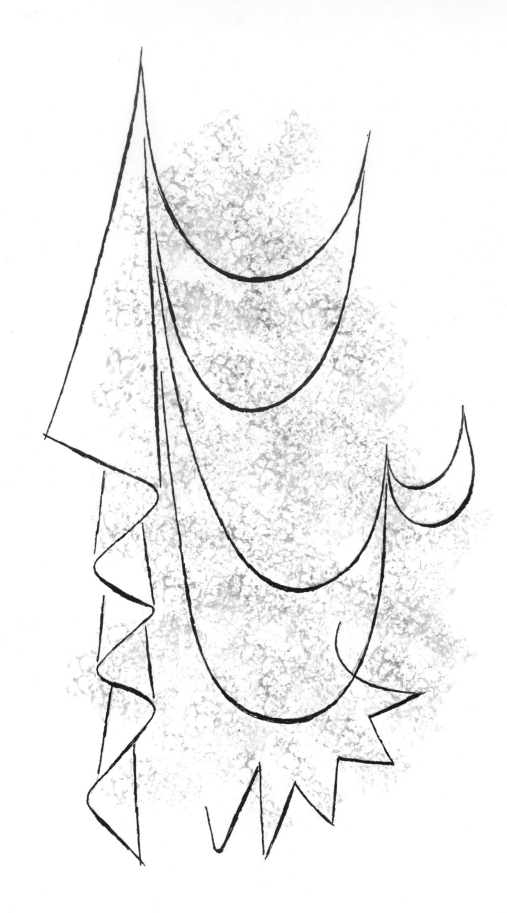

Contents

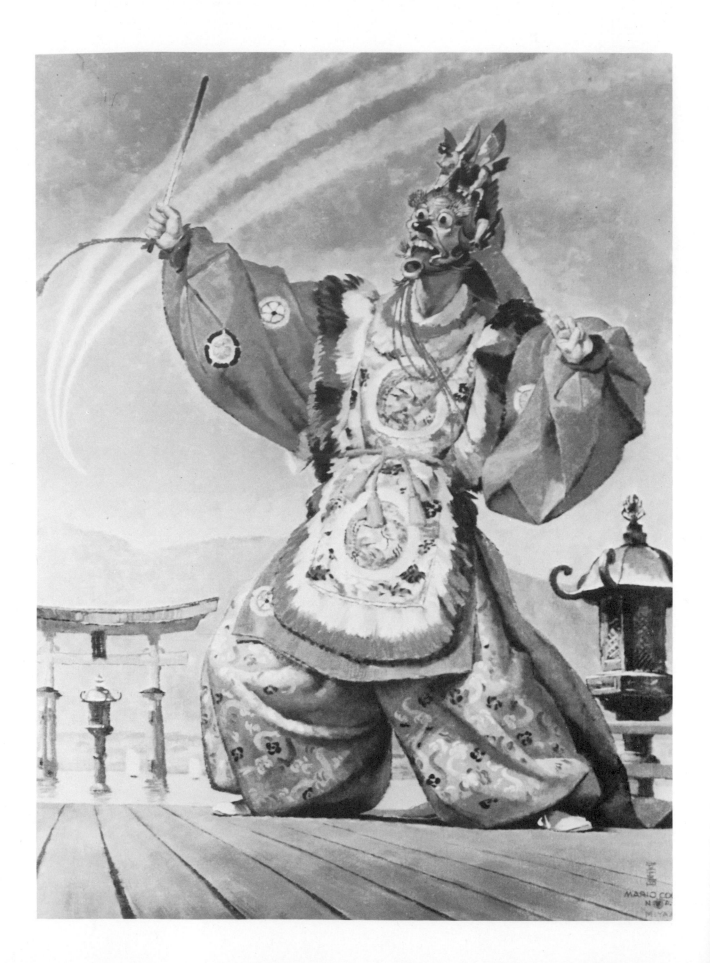

Introduction

Some of us paint or draw drapery because we have to, some of us because we like to, and some of us because we understand its potential artistic, dynamic, and decorative contribution to a work of art. There are vast differences between wrinkles, folds, and drapery.

As a fiction illustrator for the top magazines in the mid-1930s, I became fascinated with the subject and loved depicting southern belles in their intricate hoop skirts (see page 87). I also learned that an "anatomy" of drapery exists that can be reduced to a system of graphic patterns that radiate from tension points as grasses do from seeds. Through my teaching techniques acquired by many years of experience, I will demonstrate a working system for depicting drapery.

Nothing has been more frustrating to me than watching art students struggle through a web of folds and wrinkles and ending in a heap of tangled mess. When the model poses with all her clothes off they do much better, and a modicum of anatomy will serve them well.

Bugaku, temple dancer in Miyajima, Japan. By the author, from the collection of the U.S. Air Force (oil, 30 x 40 in).

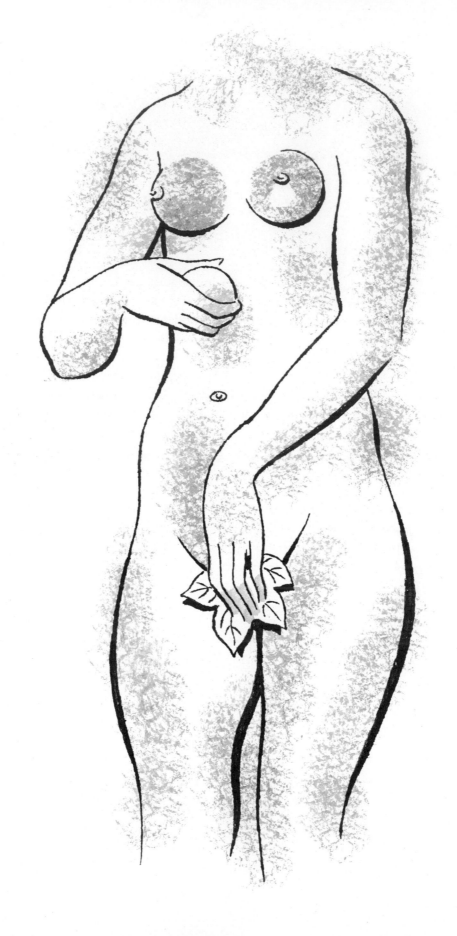

Where did drapery come from? I suppose that it was homo sapiens protecting themselves against the elements once they emerged from their caves, using the skins of animals, fronds, woven reeds, and grasses for protection. I really think the whole thing started with an apple and a snake. Eve, after taking a few bites from the fruit, discovered that a metamorphosis had taken place. After being gloriously nude, she was chagrined to discover that she was naked and ashamed, and hastily grabbed some leaves to cover what she thought should be covered.

We are concerned mainly with drapery in regard to the drawing and painting of it. As an illustrator, I had to depict drapery under all conditions—men's and women's clothing, curtains, tablecloths, napkins, pillows—name it and I drew it. I learned to love and enjoy it. My enthusiasm for the subject has never diminished, and maybe I can impart a great portion of that enthusiasm to you in the following pages.

As you observe the different forms of drapery, certain patterns will emerge from the various tension points. I have cataloged some of these forms in the Appendix with alphabetical labels. Occasionally, I refer to them in the text.

Eve, drawing by the author from the sculpture by Antonio Rizzo in the Doges Palace, Venice, Italy.

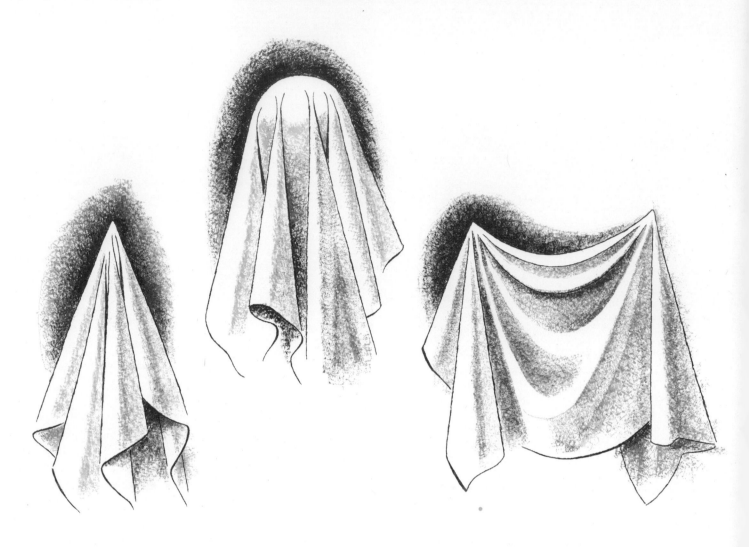

Basic Tension Points

Figure A shows a drape over a sphere. Here the tension points run around the sphere like jewels on the base of a crown. The drape falls free from these points making hemicones as they descend. Falling drape from a point usually takes on the form of a cone, but as it continues it has a tendency to impregnate itself with a concave cone, forming a left convex, a middle concave, and a right convex.

Figure B has a drape over one point. Again as the drape falls it makes conical forms.

Figure C drapery falls between two tension points to form catenaries, the slack lines that moor a ship to a dock.

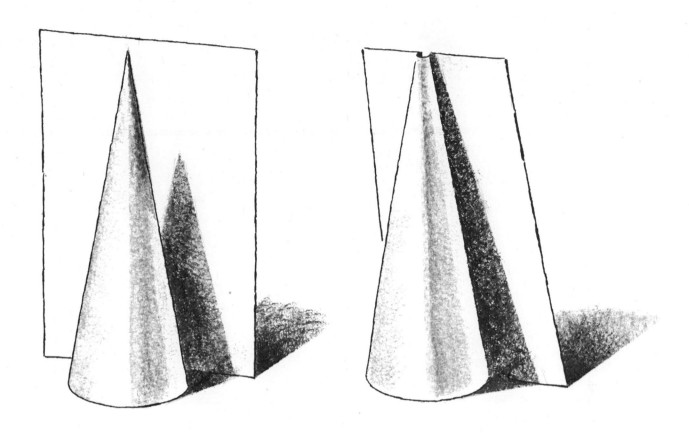

Reflected Light

Reflected light is very important in drapery, as elsewhere. Working with strong lights can allow shadows to remain in the tonal pattern as luminous areas. Figure A shows a cone in front of a vertical panel. The shadow of the cone is darker on the panel than on the cone because the cone is receiving reflected light.

Figure B shows a panel that is leaning against a cone, so that the shadow cast by the cone runs its full length, and the reflected light retains its full strength to the top.

10

Letters and Letter Parts

Drapery makes lines and lines make letters. Roman capital letters are made of lines—the straight line on the I and the curve of the O—but they are organized lines and can aid in forming a kind of alphabet out of a confused, sprawling, and uncontrolled mess of wrinkles. In the Appendix I have included various patterns frequently used to depict the many forms of drapery. These are referred to in text with letters of the alphabet.

Incidentally, the Greeks associated the triangle, circle, and square with great importance. The Chinese thought the triangle, circle, and square represented heaven, man, and earth, respectively.

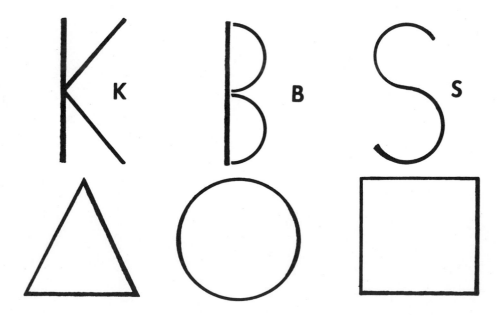

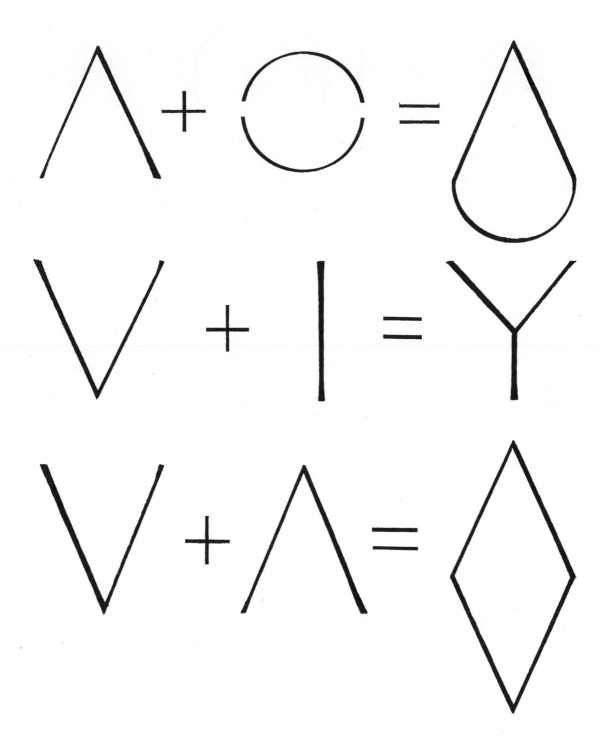

Circles, Fish Scales, and Crescents

Different combinations can be formed with the V, the inverted V (an A without the bar), and the circle.

One of the most popular forms is the circle, 1, and its parts, especially the half circle, 2. Using the half circle in concert with other circles is what the Chinese call fish scales, 3. The beauty of this design is that you can add or subtract scales and it still looks good. It appears frequently in Oriental design.

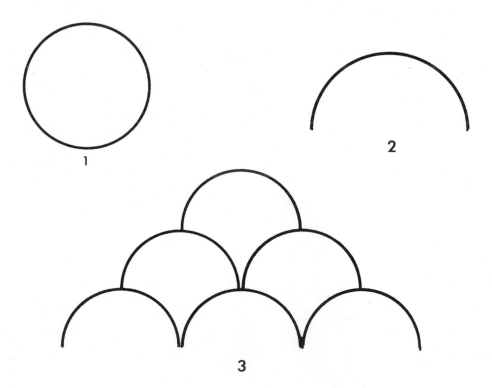

4 **5**

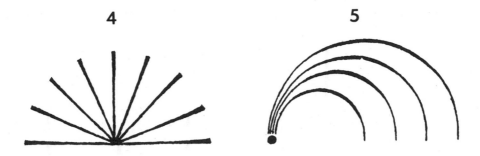

From the hub of the half circle (tension point), you radiate spokes to make a fan shape, 4. This is the key to tension in drapery. Taking the hub of the half circle, 5, and adding circles of diminishing diameters achieves a plumed effect. In 6, we have the famous catenaries that the Greeks relied on so much. The crescent, 7, is one of the most useful forms in drapery and a great contribution to any design. Parts of it are used as horns, arrows, bows, and so forth.

6

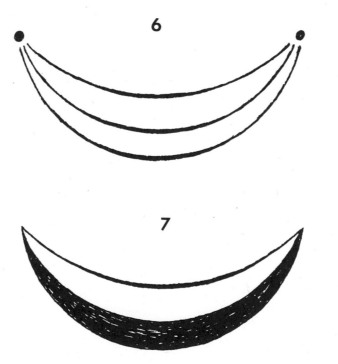

7

Tension Points in the Human Figure

Generally speaking, there is a very little difference in the tension points between male and female dress. Obviously with exotic dress and costumes there are exceptions, but tension points are tension points, and whether male or female I'll point them out. Starting on the front of the female on the left they are the knee, crotch, hip, wrist, waist, elbow, armpit, breast, shoulder (deltoid), and neck. On the back, there is the back of the knee, the buttocks (gluteus maximus), waist, elbow, armpit, shoulder blade (scapula), and the back of the shoulder and the neck.

The tension points of the male are the knee, crotch, wrist, elbow, pectoral muscle (on the male it does come into tension from time to time), shoulder, and neck. On the back, the calf (gastrocnemius), back of the knee, wrist, buttocks, waist, armpit, shoulder blade, shoulder, and neck. The woman's calf is usually a little less muscular, her hips wider, and her shoulders narrower. The man's waist is narrower. An important difference is in the neck: a woman's neck is longer and thinner; a man's is shorter and huskier, like a football player's neck.

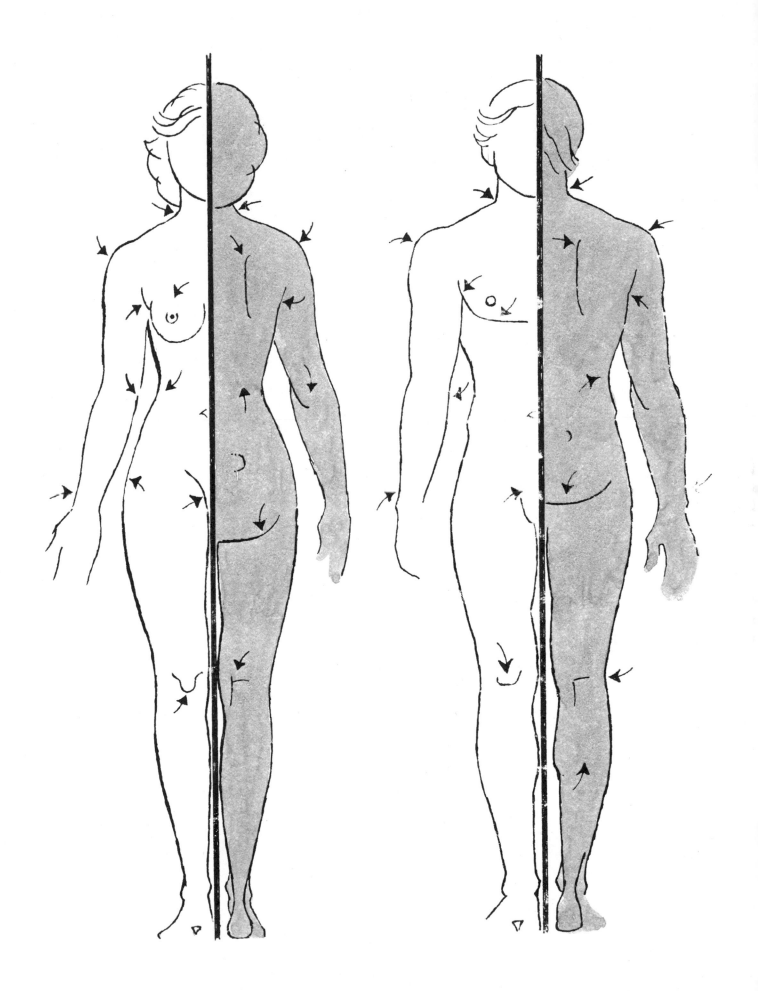

Zigzags

Drapery at times falls in uninspiring shapes. In the left diagram is a drape with a silhouette that does not take full advantage of the design potential. By applying the zigzag to it as shown on the right we have a much more interesting shape. The zigzag is greatly used in art as we shall see as we go along. I used the zigzag in the sculpture that I carved of the *Madonna and Child* on the opposite page.

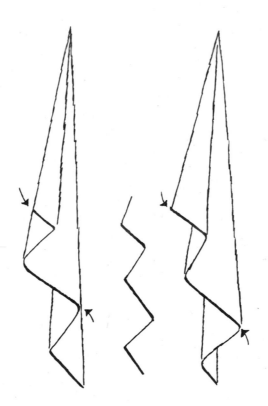

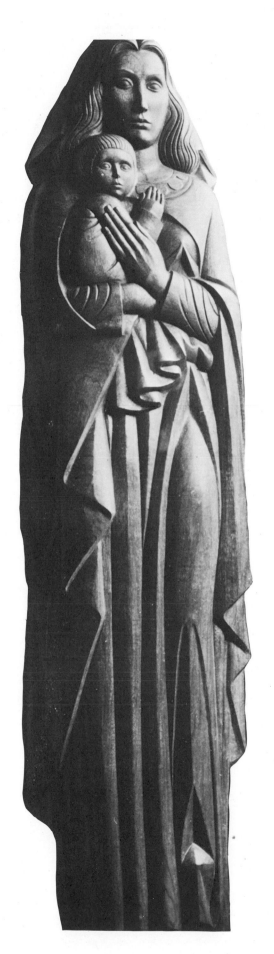

Madonna and Child by the author, Saint Luke's Hospital, Denver, Colorado (wood, 4 x 15 x 60 in).

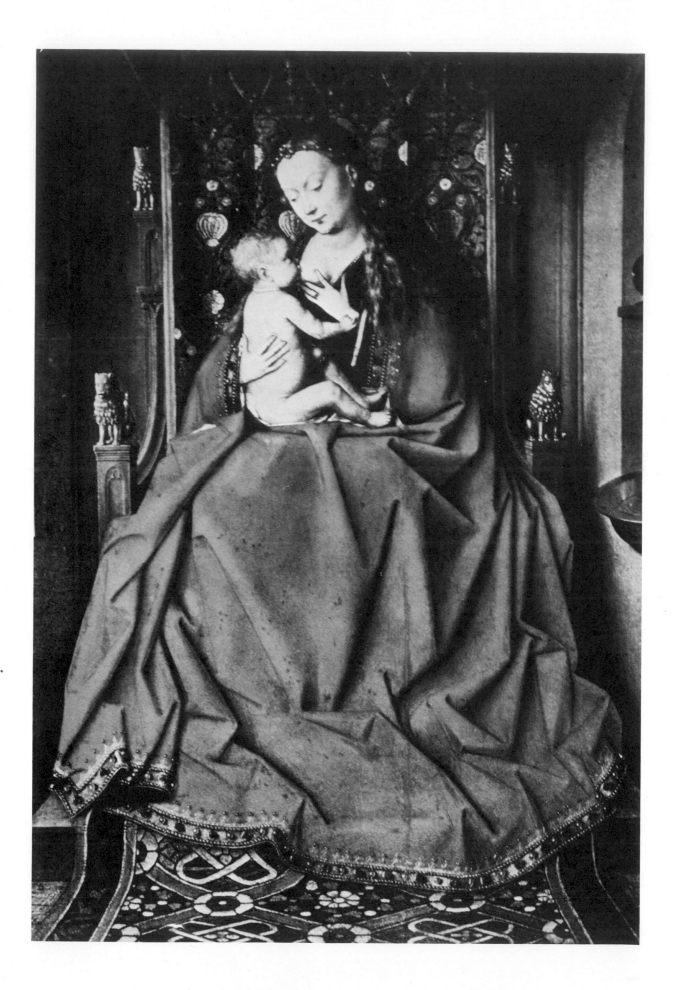

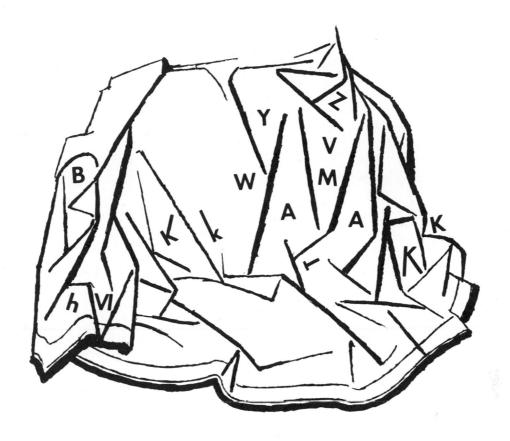

The Van Eycks elevated drapery to an elegant degree in art. To study the drapery in their paintings is to enjoy visual music. To better point out how they utilized letterlike forms I made the above diagram and placed letters that most resemble the folds in the drapery. Some folds resemble more than one letter—or form part of another, such as a V being part of a W, or an inverted V making the letter M. Roman numerals can also be made out like VI or XII for example.

Lucca Madonna, by Jan Van Eyck, Städelsches Kunstinstitut, Frankfurt (c. 1390–1441).

15

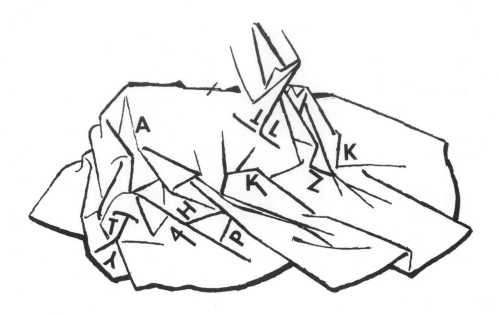

Again with Saint Barbara, I placed letters that resembled the folds. I do hope that the letter placement won't keep you from finding other calligraphic symbols or signs. You might find the Gothic Runic alphabet interesting (most dictionaries have examples of it). I have drawn a few characters below. As you can see, there is a method to an artist's madness.

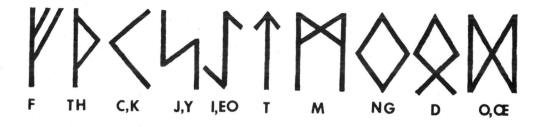

16

Saint Barbara, by Jan Van Eyck, Antwerp Musée Royal (18.5 cm).

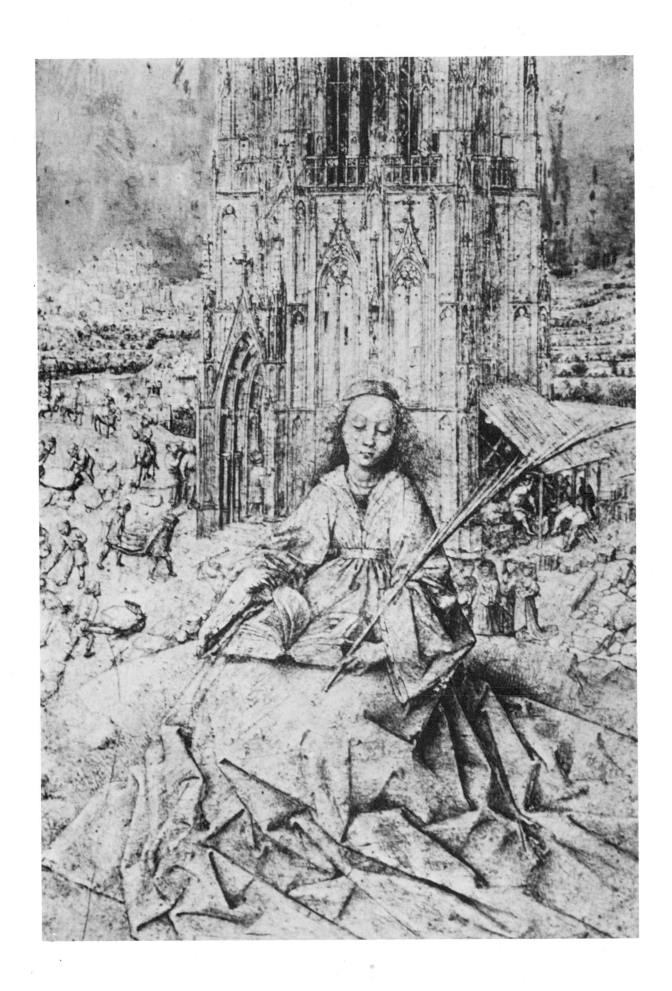

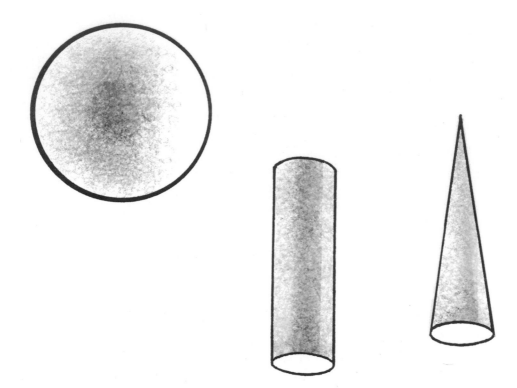

Geometric Solids and Calligraphic Tension

What we are concerned with is mainly the drape around the human figure, which means that we have to cover geometric solids. If the buttocks (gluteus maximus) is like a sphere, arms and legs are cylindrical and conical. It is the tension points around these forms that make the anatomy of drapery. This differs from some of the Van Eycks' fallen drapery that is crumpled and virtually without any tension, making only an interesting decoration.

18

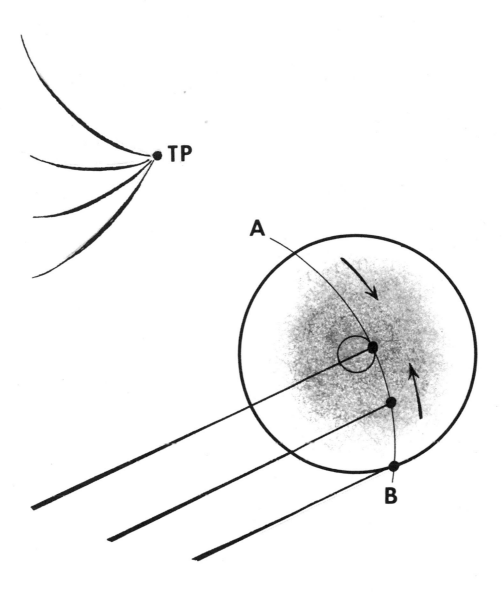

Most tension points are singular and the drapery in action fans out seeking the form it wraps: sphere, cylinder, or cone (TP). When a sphere is involved, the tension points are numerous and spotted along the middle or equator, A–B. The drape tends to attach itself to the one half like a skin (see arrows) while the other half strains with its multiple tension points.

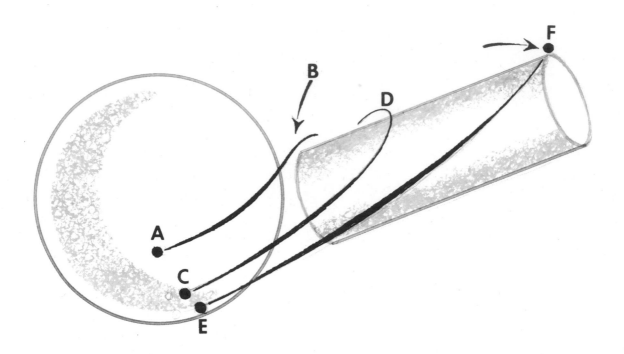

One of the most overworked sections of the body is the area we sit on—the buttocks and the upper part of our legs. We can regard the buttocks as a sphere and the upper part of the legs as cylinders. The most important fold is the hinge between the sphere and the cylinders of the leg, A and B (see page 24). The tension point of the sphere, C, lassos the cylindrical thigh, D, while E is in marked tension with the knee at F.

The portrait of Madame Hamelin, by Jacques-Louis David has the CD and the EF tensions well in evidence. The AB hinge is screened by a casual drape cascading from the French high waist of the period that falls between her legs. Another tension point in the portrait (there are many) is made by her pressing her gown against the seat of the chair. It fans out from a vertical position to an almost horizontal one as it ends just below the knee.

Madame Hamelin by Jacques-Louis David (1748–1825). Chester Dale Collection, National Gallery of Art, Washington, D.C.

20

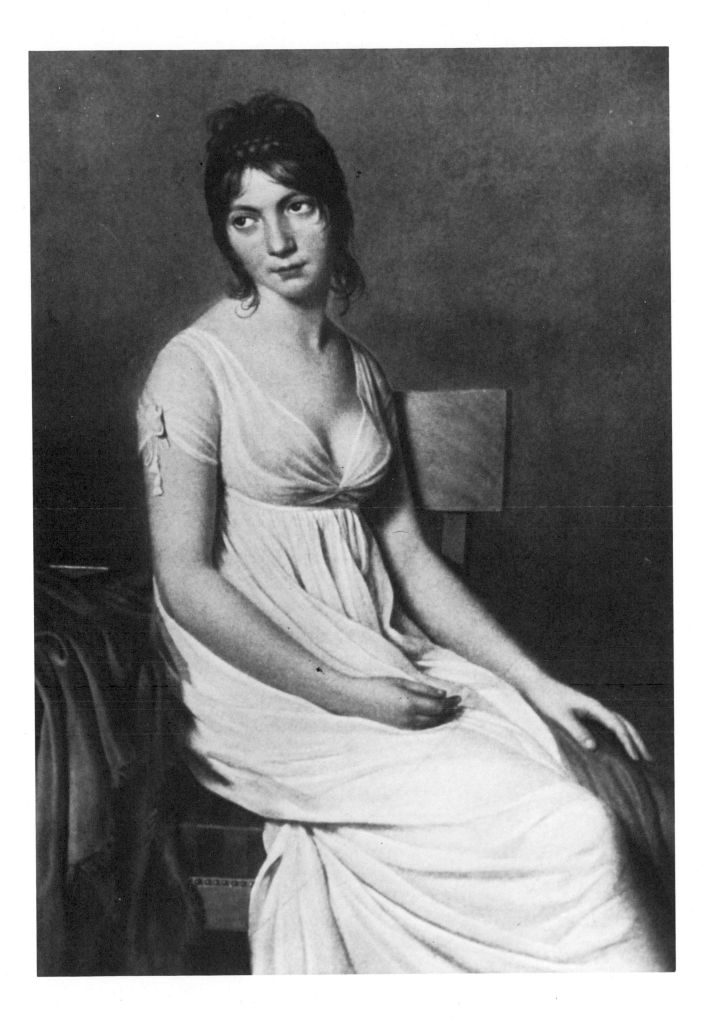

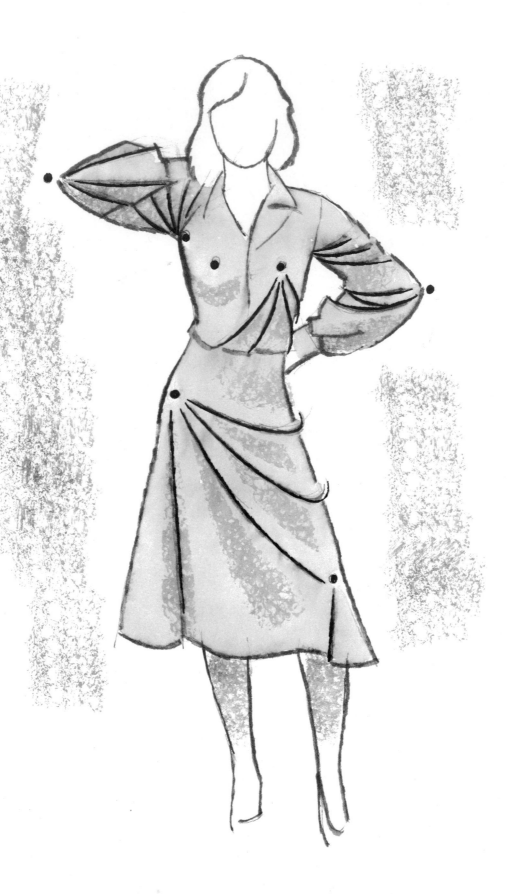

Mechanics of Folds and the Hinge

The figure on the opposite page shows the main tension points and the channels they make to their destination. Remember that in most cases the folds will fan out from their tension points: elbow, armpit, nipple, waist, hip, and knee. In the portrait of Madame Hamelin, the fashion of the gown made tension points between the breasts turning them into hemispheres and distributing the tension points in a ring around the nipples.

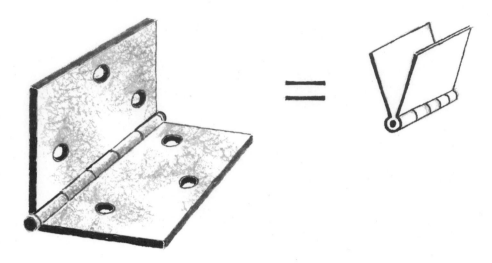

There are many parts of the human figure that work like hinges: parts that bend sharply like the elbow, knee, and the torso as it meets the legs.

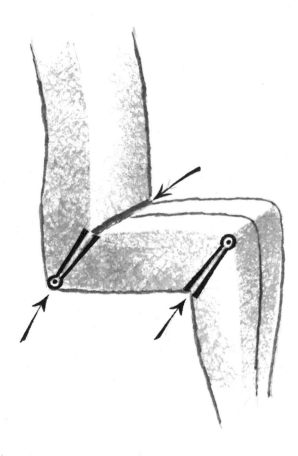

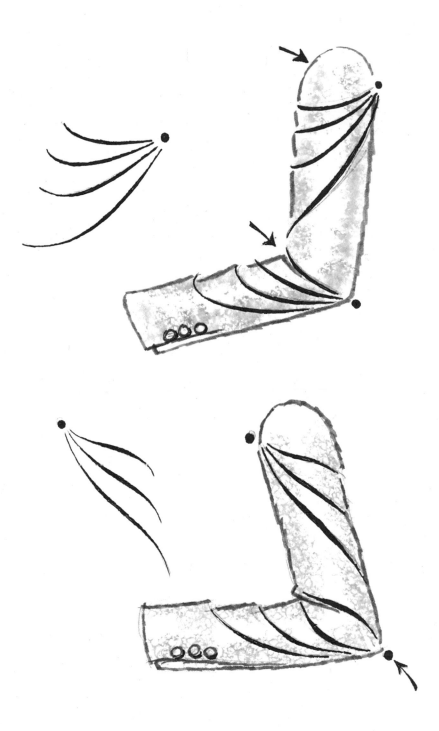

Shown above are the radiating and fanning of the folds from the tension points of sleeves.

The sitting position is probably the most difficult to depict. The torso, the upper part of the legs, and the lower part all bend in a zigzag formation. The buttocks and the upper part of the legs and knees form the key points of tension.

The function of the different points starts with A, which shows the trouser leg quite a bit away from the leg, while at B the trouser is pressed against the leg. This makes for variety in design. At C, the knee's tension lines fan out between the calf, CC, and the buttocks at F. Behind the knee at D, we get the hinge as well as at E.

The figure showing the skirt has generally the same tension points, except that the folds from C to CC fall free.

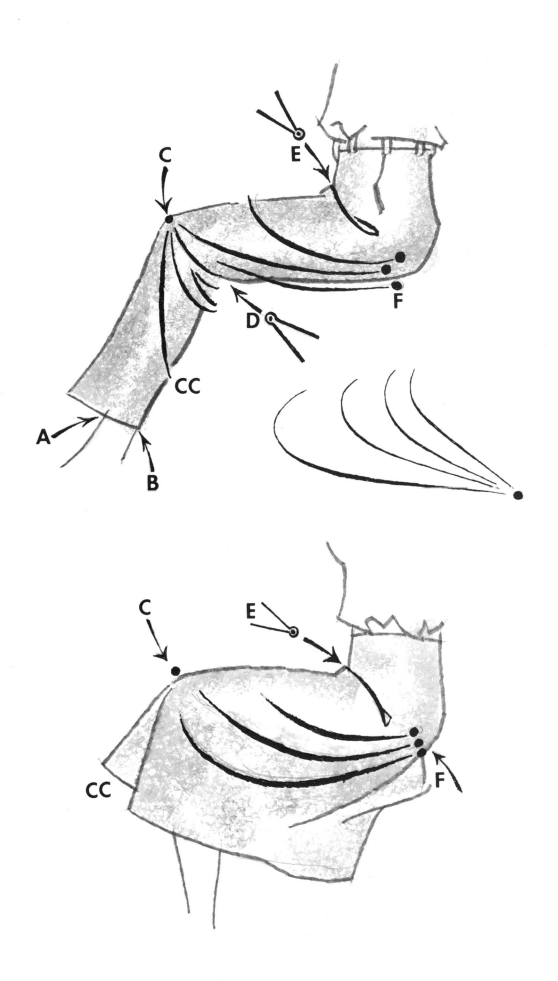

The Seated Position

Drawing trousers in a sitting position can be a problem, but here again all you have to do is to remember where the tension points are located. In diagram A with the legs spread out, the tension points are from the knee to the crotch and from knee to the back of the lower leg just below the calf (gastrocnemius), at 02. The tension lines from the crotch to the knees radiate like cat's whiskers. The back of the knee (the hinge, 2) starts the radiation of the back of the lower leg and ends just above the ankle pressing tight to the leg at 7, although at 6 the trousers spring away from the shins (tibialis anticus). The fold that starts in tension at 1 dissipates as it falls toward 5 and 6. At 4, the torso and the upper leg form a hinge. In B, the cat's whiskers are constricted at 8 and turn into plumelike curves, as the lines wrap themselves around the spherical upper leg.

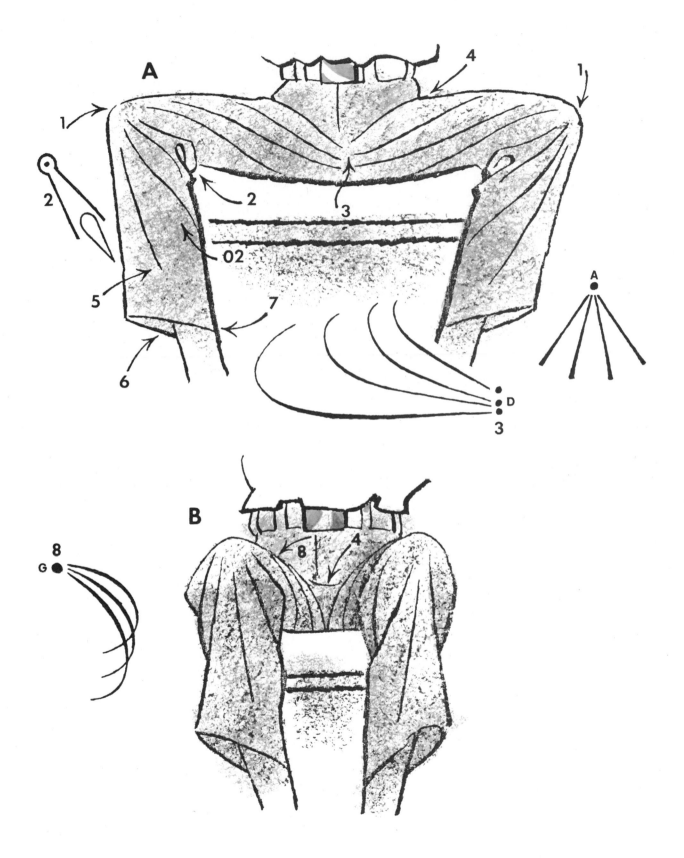

When showing the sitting position, one of the problems is not knowing what is under the drapery. One of the most common errors is not letting the knees come high enough so that the upper leg from the knee to the body is more or less in a horizontal position. A very famous illustrator, Dean Cornwell, used to bob the legs of his studio chairs to make sure that the models' knees were high enough when seated.

The most important fold in a sitting position is the hinge that takes place between the torso and the projecting legs, and, whether skirt or

30

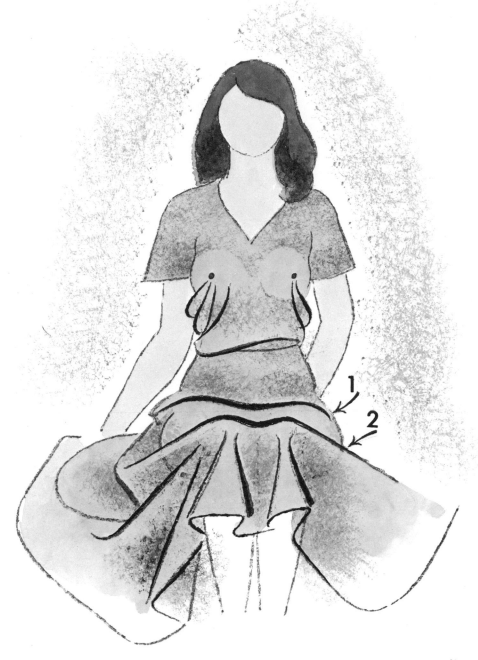

trousers, the fold has to describe the change from torso into two cylindrical legs. In the case of a skirt the lap acts like an awning suspended between two cylinders, so that the terrain of the lap becomes two hills with a valley in between, that is, convex, concave, and convex. The knees are more likely to describe a catenary between them, 1 and 2. A skirt as well as trousers will drop a conical drape from the knee, the apex being always at the tension point.

The breasts are almost always in tension with the waist. See pages 37–45.

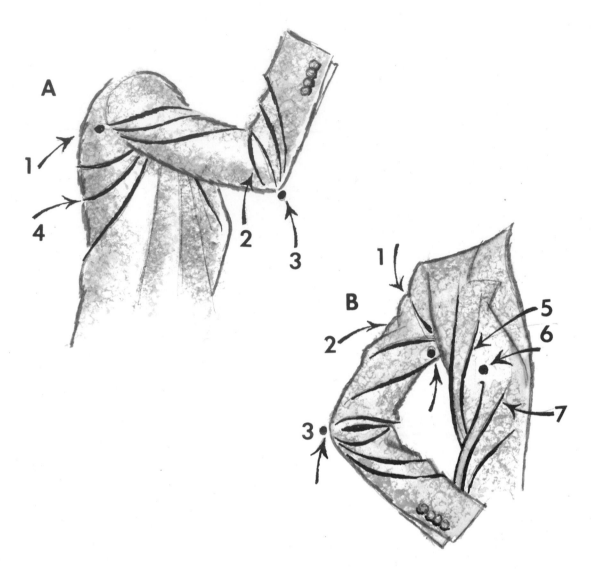

The arms, of course, get most of the action. The main areas are the armpit, the elbow, and the outside of the shoulder. Notice how in A the line that starts at 1 outlines the shoulder muscle (deltoid), which acts like a shoulder pad. At 4 the shoulder blade is in tension with the armpit. At 2 notice the hinge. At 3 the elbow radiates with the forearm.

In B, at 1 the fold outlines the shoulder muscle and heads for the armpit. At 2 the radiation swings from one side to the other, making a V shape. Line 3 is pulling from the armpit. The hinge also starts at 3 and also is engaged in a tension pull with the lower arm. This jacket is on a female so that the nipple belongs at 6. Line 5 swerves around the base of the breast. Line 7 is in tension with the base of the hemisphere (breast).

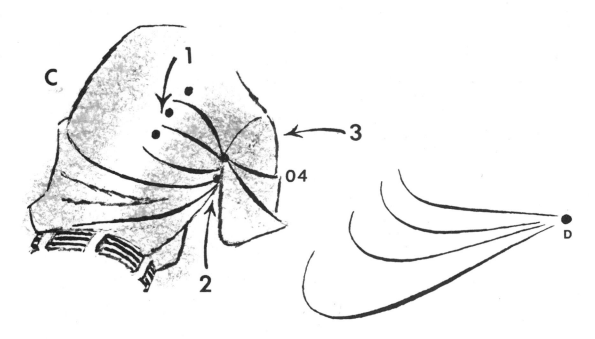

In C, the armpit at 2 is in tension with the waist and back, tugging at the shoulder blade at 1 (scapula). The shoulder muscle (deltoid) is generally defined by a tension line, 04. The deltoids are like shoulder pads on a football player.

In D, the elbow at 4 is in tension with the armpit at 5. While the tug of war is between 4 and 5, the tension lines at 5 radiate from the elbow to the deltoid. The tension lines on the right arm between the armpit and the elbow just wrap themselves around the arm and end at 4. Notice the hinge on the left arm at 4.

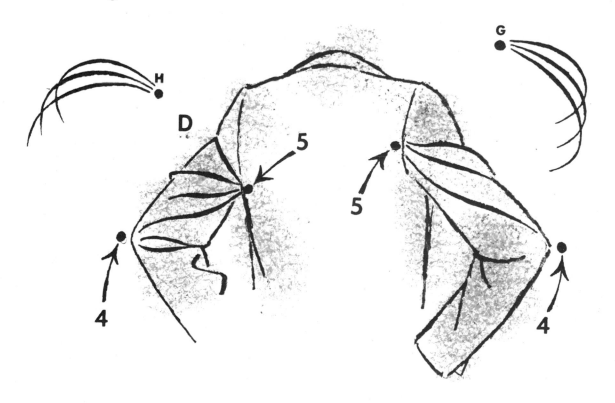

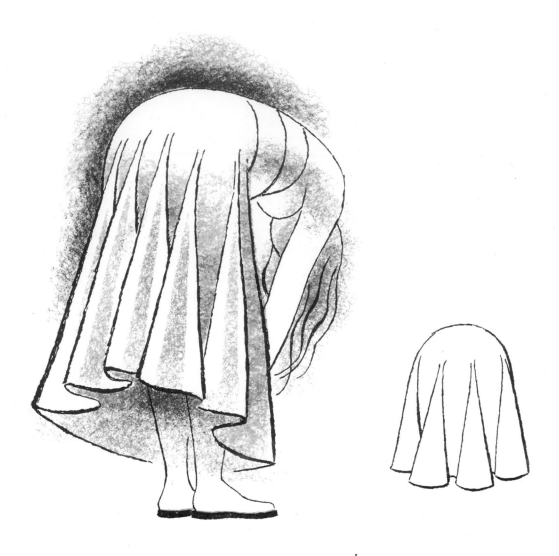

Hemispheres: Buttocks, Shoulders, and Breasts

Bending forward, a loose gown or skirt will drape over the buttocks (gluteus maximus) as if it were a sphere and tension points will distribute themselves around the equator dropping conical folds from their points.

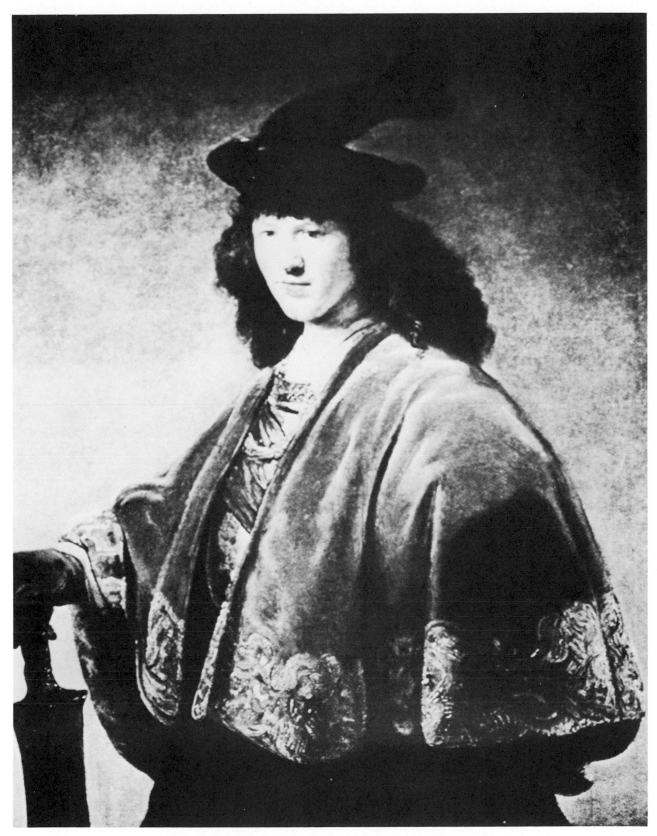

Young Man with a Sword by Rembrandt Van Rijn (1606–1669). Samuel M. Kress Collection, North Carolina Museum of Art, Raleigh. Note that the left shoulder of the young man acts like a sphere under the cloak and you can see the folds from the tension points on each side of the arm.

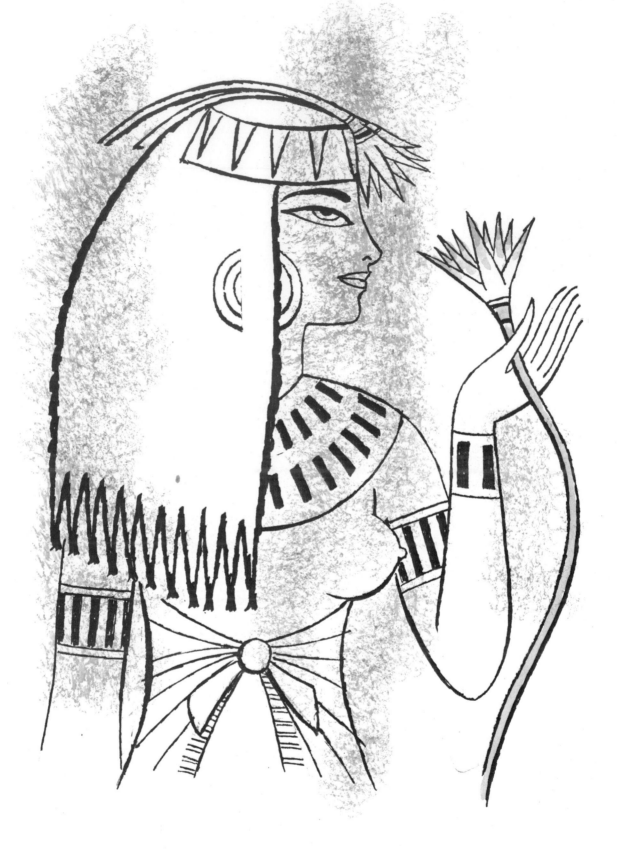

Egyptian Princess by the author.

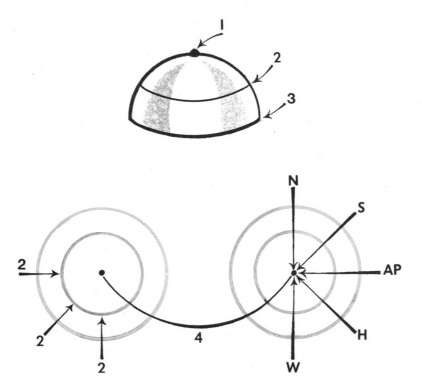

The egg may be nature's sublime form of all spheroids, but for a hemisphere, the female homo sapien breast has the most exquisite variety of form and line. This was appreciated by the Egyptians, Indians, and Balinese, and they exhibited the nude breast with elegance.

But drapery over the breasts presents problems. To simplify the action of the drapery over the breasts, think of them as hemispheres and their nipple as the "north pole" 1. The "equator" (3), is where the breast connects with the chest. The drape action is quite different than that of the buttocks, where most of the time the drape falls free.

The breast is always in tension with other areas: the waist, the armpit, and nipple to nipple. There are two tension areas in the breast: one is the nipple, 1 (the north pole if you still have the northern hemisphere in mind), and the other is between the nipple and the "equator," or the "40th parallel" at 2.

Nipples can radiate folds to the neck N, shoulder S, armpit AP, hip H, and waist W. They can also form a lot of catenaries between them. The middle part of the breast, 2, can also radiate in a number of directions (see page 39).

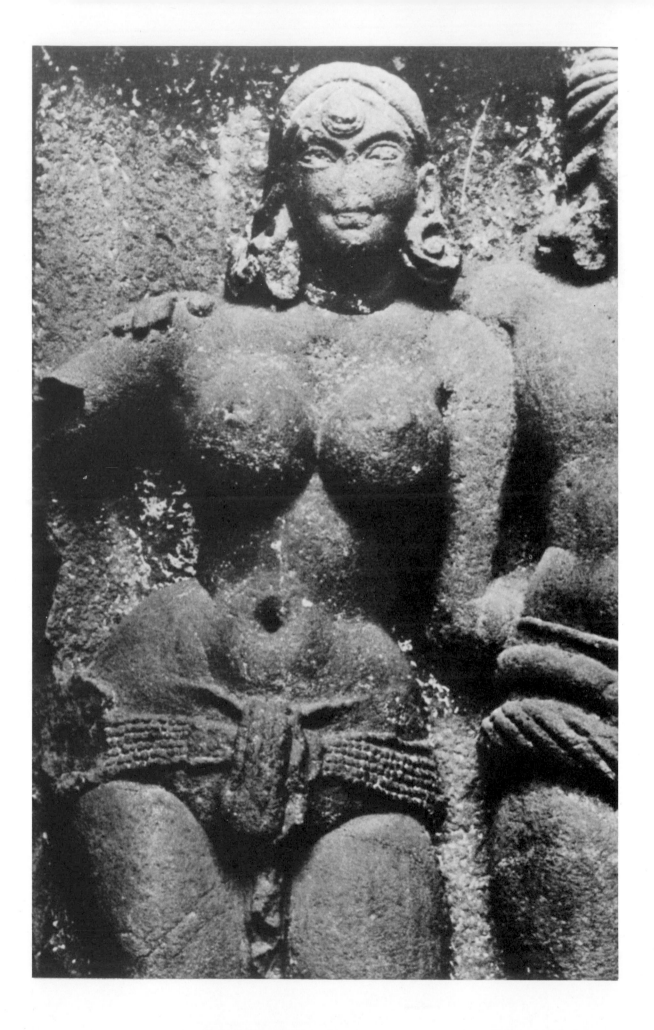

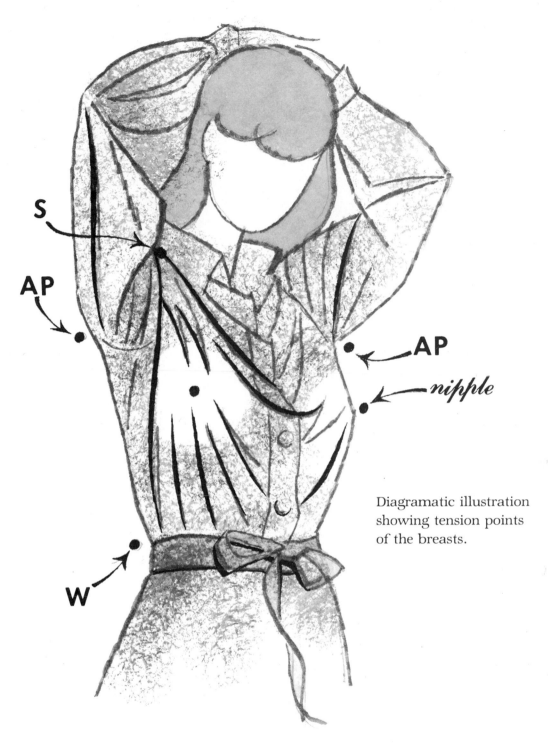

S

AP

AP

nipple

W

Diagramatic illustration
showing tension points
of the breasts.

Dampati appearing on the facade of a
rock-cut Buddhist temple, Karle, Bombay,
India (c. 100 B.C.).

39

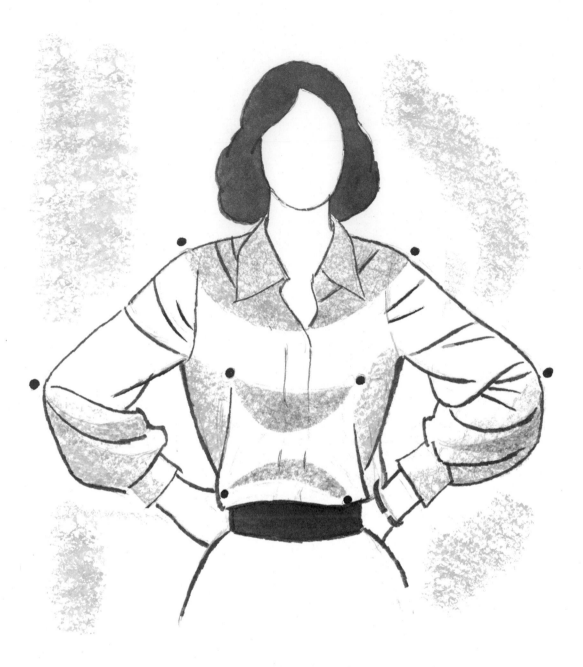

While not always dominant, tension points can influence areas, creating shapes that are dynamic as patterns. The areas on the diagramatic illustration are darker for emphasis because in ordinary lighting conditions they would hardly be evident to the layman. The patterns mostly have a moon shape—like crescents. The negative space between the crescent of the nipples and the inverted crescent of the waist looks like an hourglass or a spool. The loose sleeves make hornlike shapes.

40

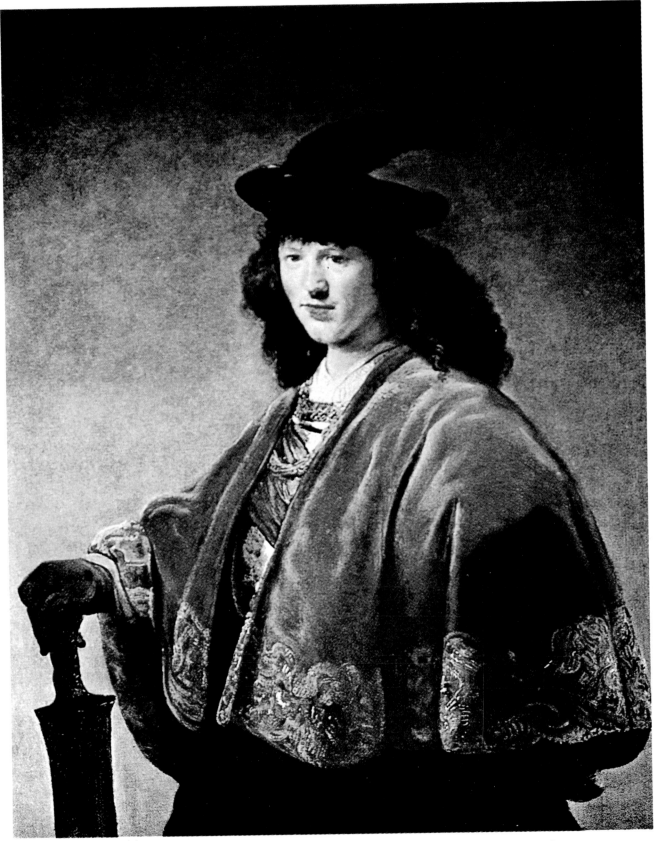

Young Man with a Sword by Rembrandt Van Rijn (1606–1669). Samuel M. Kress Collection, North Carolina Museum of Art, Raleigh. Note that the left shoulder of the young man acts like a sphere under the cloak and you can see the folds from the tension points on each side of the arm.

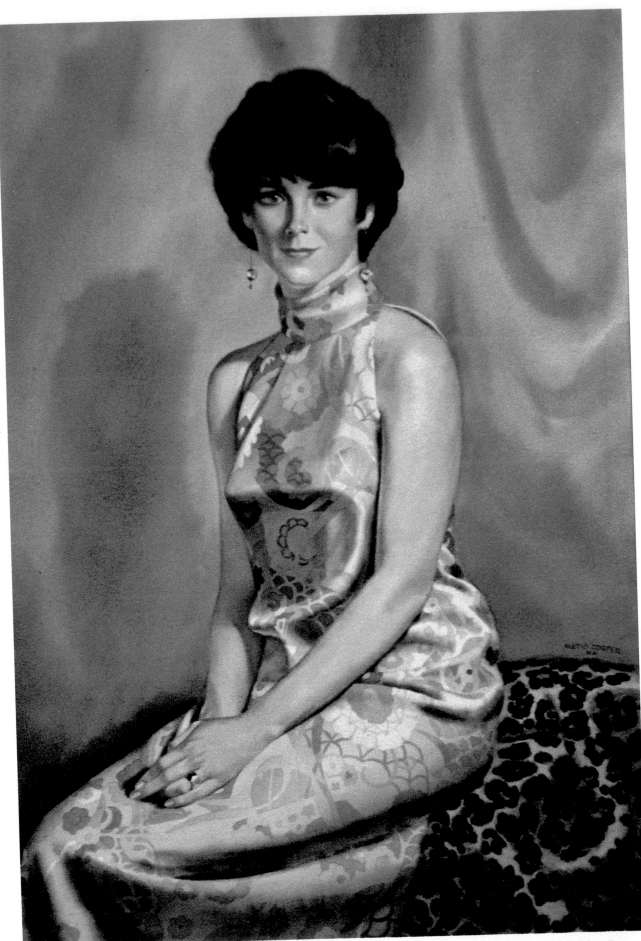

Mrs. John Hellegers (Dale, Jr.) watercolor by the author, from the collection of Mr. and Mrs. John Hellegers, Philadelphia, Pa.

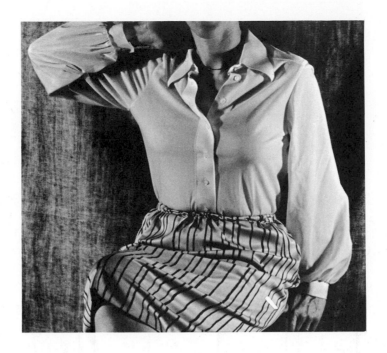

Quite often a seam will cut across tension lines, totally wiping them out on one side and multiplying them on the other, as in 1, 2, and 3. In the photograph, the left breast is in tension with the shoulder, armpit, waist, and right breast. The tension lines radiate like spokes on a wheel—what the right side would be doing had not the seam interfered at 2. As the seam loosened at 4, the tension lines between the left breast, the right shoulder, and the neck began to exert themselves, 4↔4 to the left of 3. In the diagram, 6 and 7 are part of the hinge fold. Note the folds (8 and 9) describing the upper part of the left leg, with 10 being the right knee.

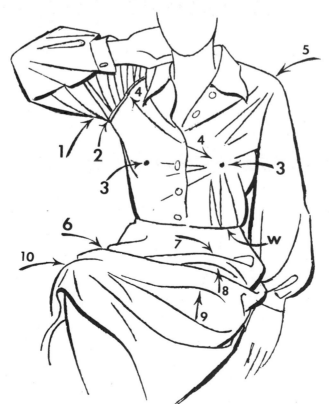

41

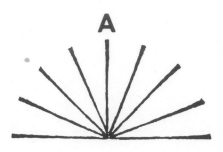

This diagramatic picture shows the tension between the shoulder, armpit, and waist. The waist is also in tension with the back. The tension lines start at the waist and radiate to the breast and back. Often the line from nipple to nipple and the slant to the shoulders form a plane that resembles the slant of a gable roof.

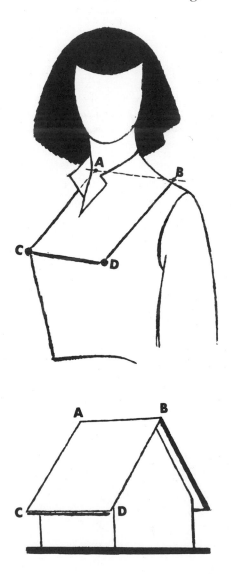

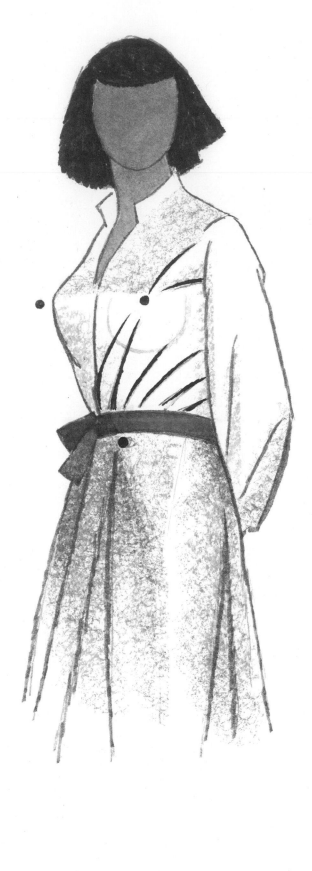

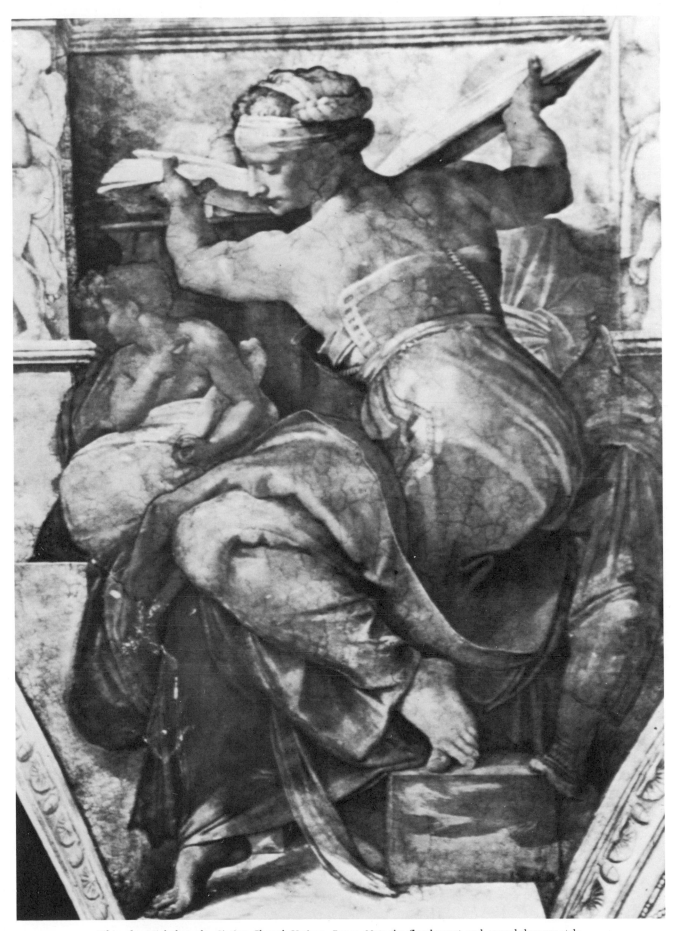

Libica by Michelangelo, Sistine Chapel, Vatican, Rome. Note the flamboyant and casual drapery style.

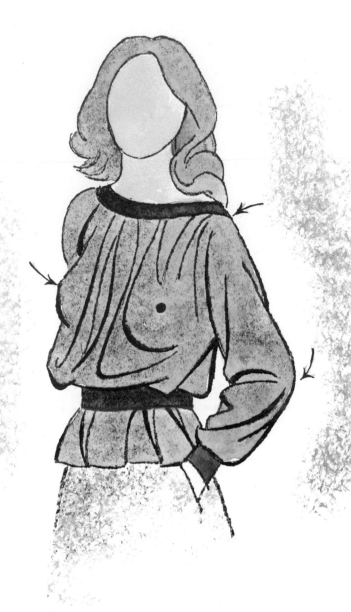

Heavy, loose garments like bulky sweaters tend to flow around the breasts very casually and you have to know your tension points to find them. In the illustration notice the main tension points at the shoulder, nipple, and elbow. There is not much at the waist.

44

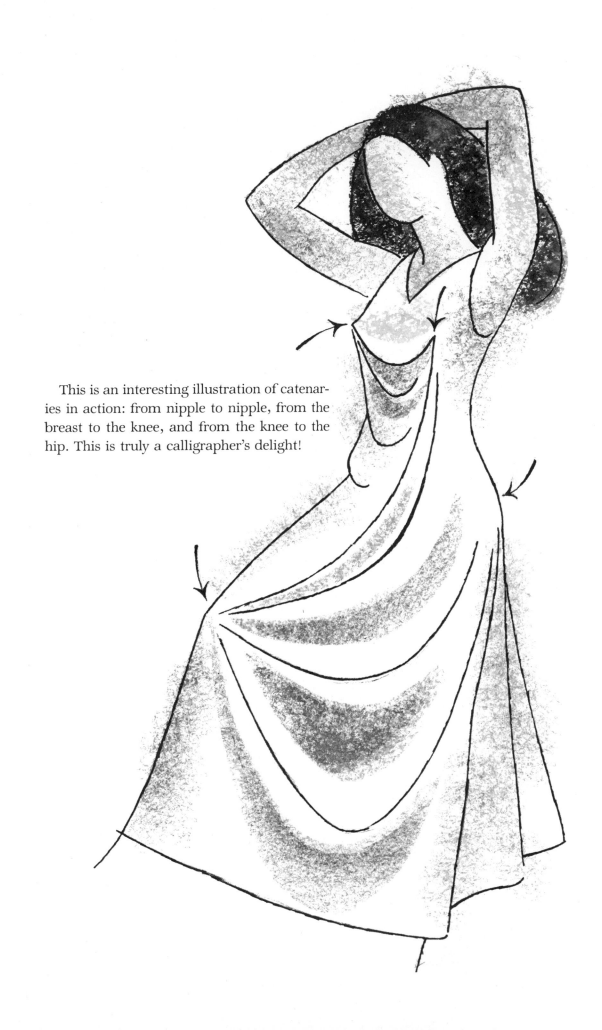

This is an interesting illustration of catenaries in action: from nipple to nipple, from the breast to the knee, and from the knee to the hip. This is truly a calligrapher's delight!

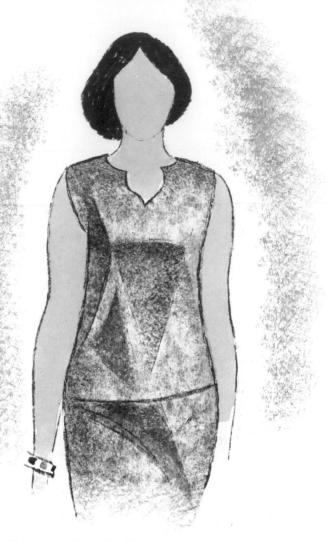

This figure illustrates how the breast can influence drapery and contribute dynamic and geometric patterns. You can make out the letter M from the nipples as the tension line goes to each hip and to just below the waist at center.

The satin gown on the opposite page lends itself to dynamic planes and patterns. Note the "hip roof" between the breasts and the shoulders, and the triangle between the left shoulder, nipple, and hip. The front, from the left breast to the crotch and hip, breaks into four triangles: the lighter and wider on her right side falling from the nipples, the left one falling from the left nipple, and the two darker ones with their base at a line between her right knuckles and her left thumb. Note the background drape on the left of the picture falling into elongated conicals and zigzags.

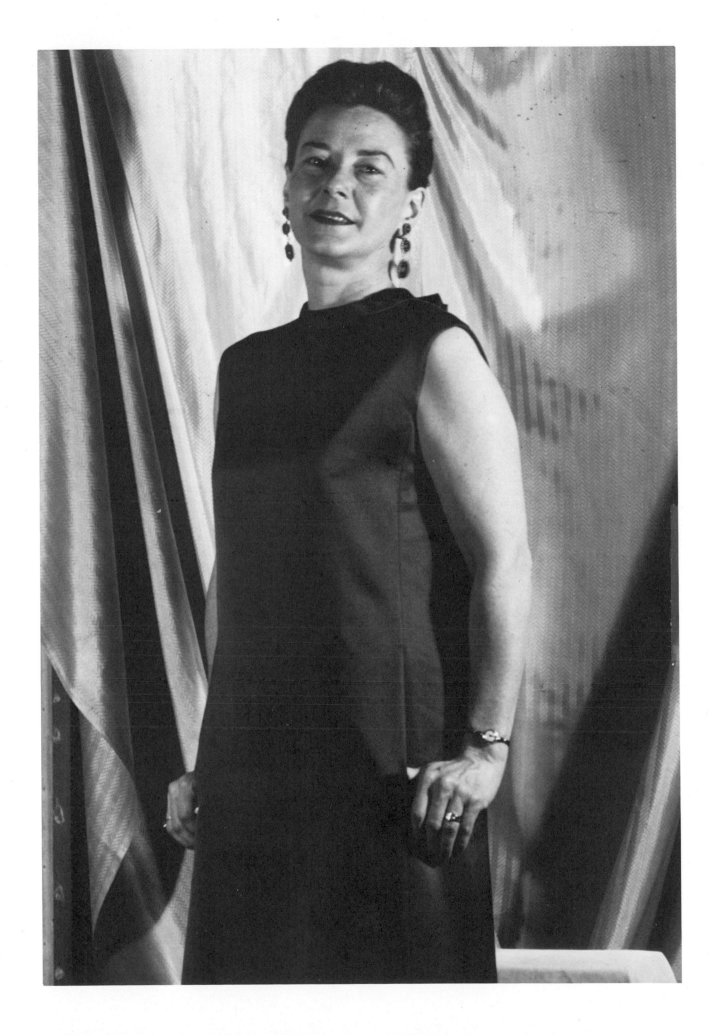

Falling drape making elongated conicals when compressed by a cord or belt will make Vs and inverted Vs. This happens with any loose garment, such as trench coats, night or evening gowns, curtains, and drapes. You will also find the "teardrop motif" reproduced in diagram G in the Appendix. Wide sleeves as they drape below the hinge have a tendency to turn into diamonds as shown.

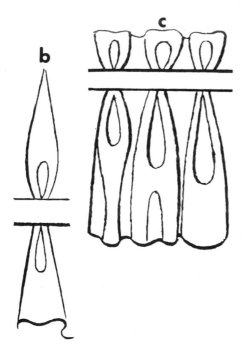

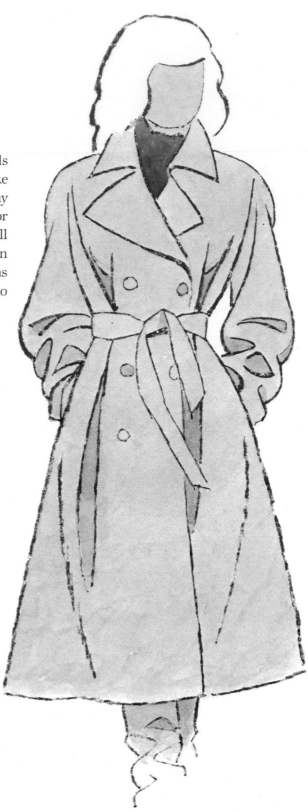

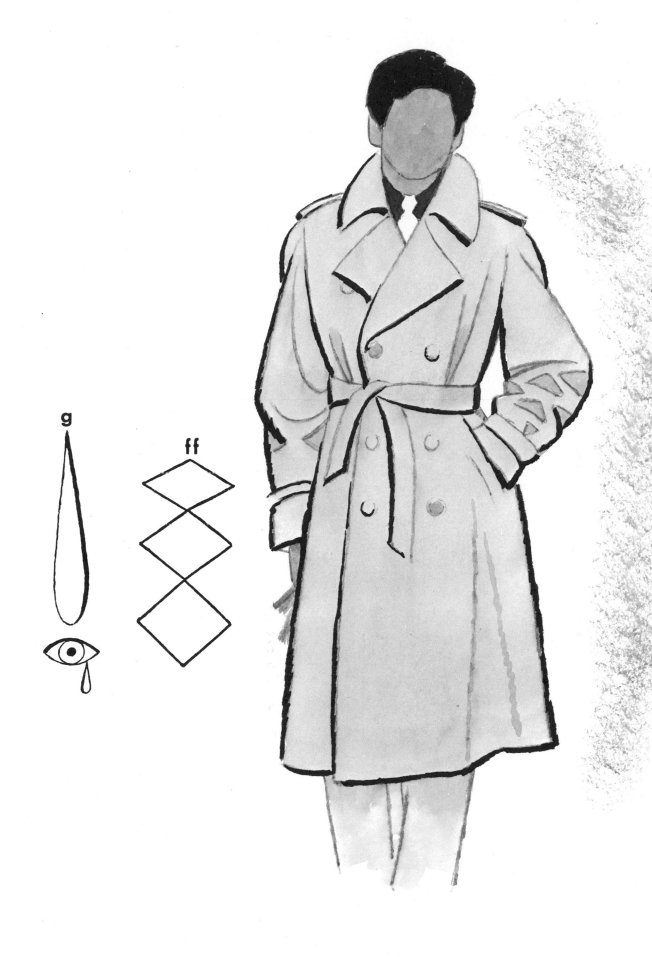

g

ff

The sculpture of Athene is an excellent example of tension points. The usual shoulder-to-shoulder catenaries are made in two triangles here. The shoulders pull handsome lines from the waist. The nipples get into the act making cones and teardrops. The sash makes a series of teardrops and loose-ending cones.

The right side of the garment drops straight down without any interference. The left side shows the drape in tension with the knee, which in turn is in tension with the outer part of the leg (gastrocnemius) just above the ankle.

Draped Figure of Athene, Louvre, Paris (marble copy of a prototype dating from 500 B.C.).

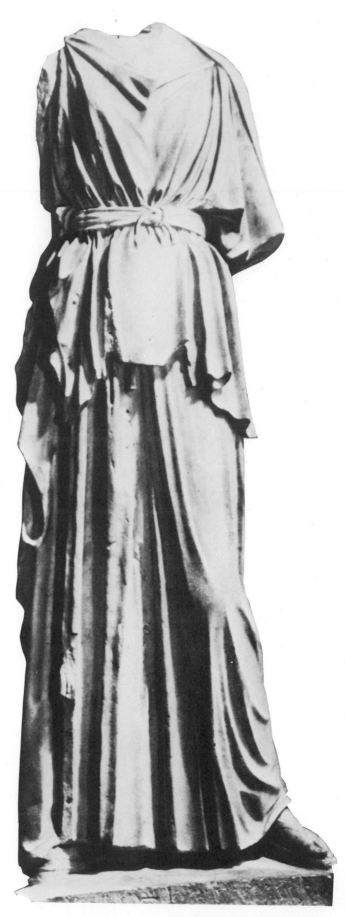

50

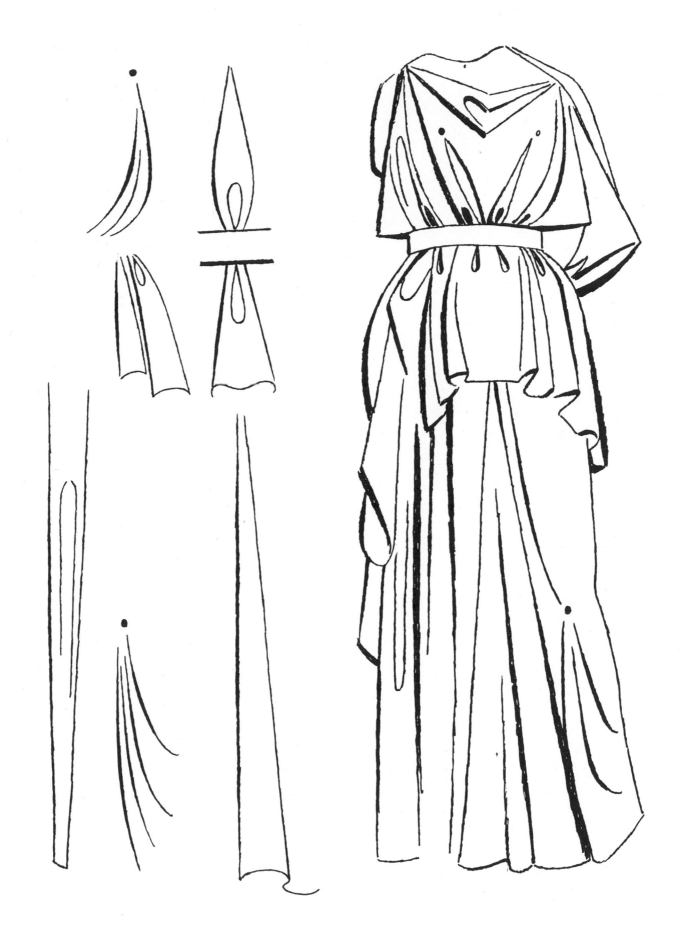

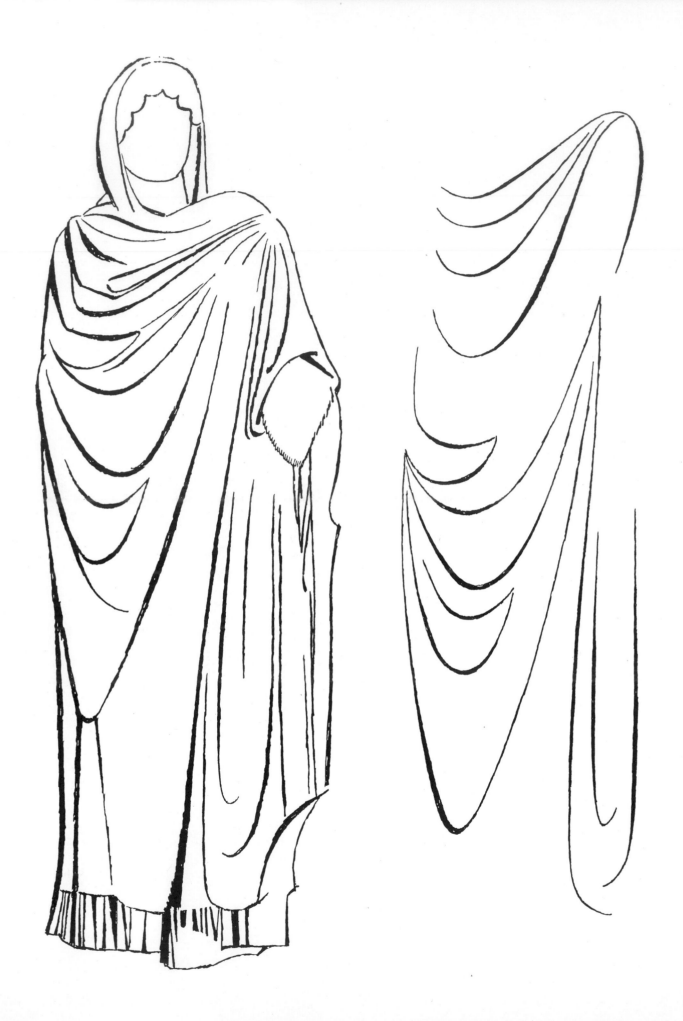

This sculpture in the Louvre, *Veiled Woman Known As Aspasia*, is a calligraphic delight! The tension between the two shoulders makes an exciting variety of catenaries from obtuse to acute. It is truly seeing linear music! It is hard not to be exclamatory about this masterpiece.

Veiled Woman Known as Aspasia, Louvre, Paris (marble, c. 500 B.C., Peloponnesian artist).

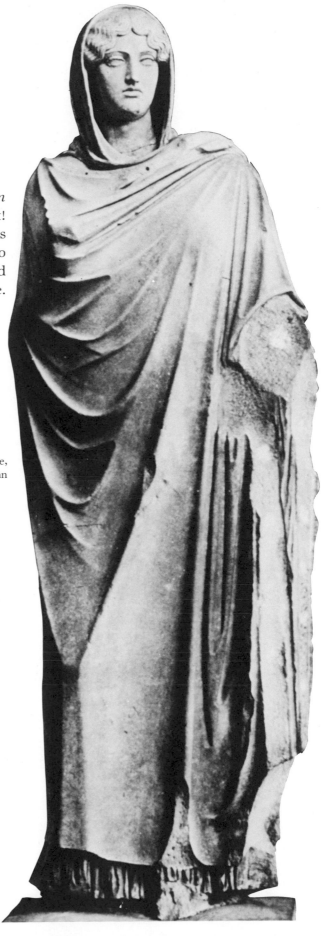

Dynamic Patterns and Calligraphy

Calligraphy is a free-flowing rhythmic line with calculated directions in which the line pulsates from thick to thin and can indicate light and shadow, as well as diminishing or increasing volume. In art, calligraphy can make a powerful contribution, especially to drapery.

For elegant female form and flowing calligraphic drapery to cover it, the *Statuette of Aphrodite* is the most impressive. The linear rhythms are so lyrical that they suggest a poetic song.

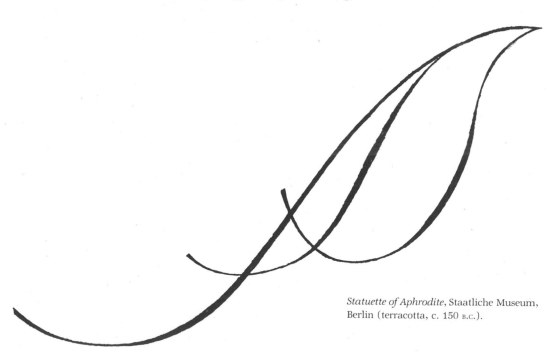

Statuette of Aphrodite, Staatliche Museum, Berlin (terracotta, c. 150 B.C.).

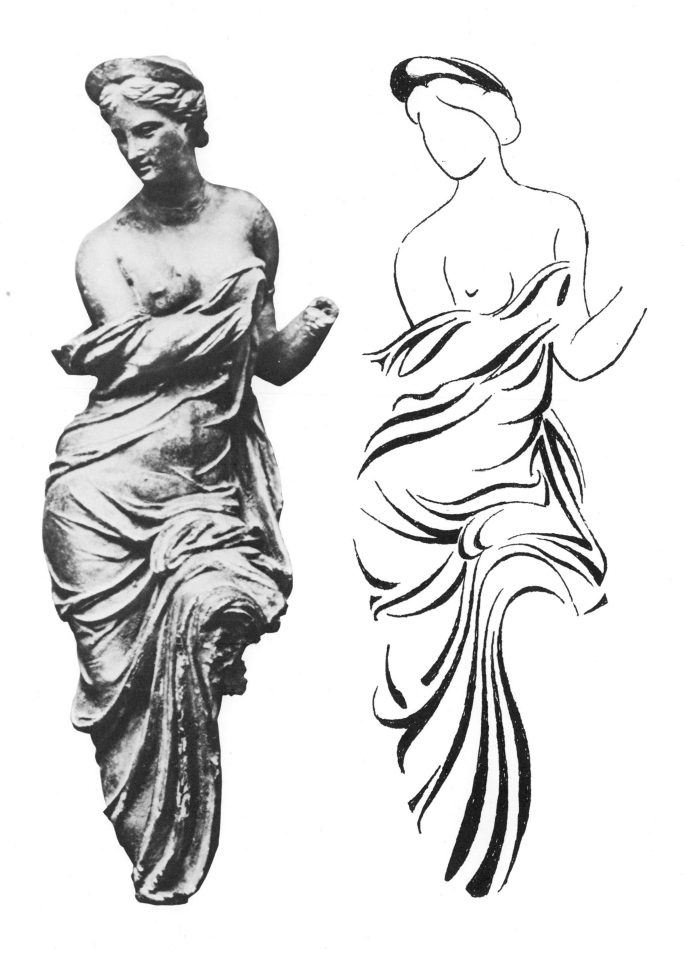

Sleeves, Bellows, Diamonds, Catenaries, and Crescents

Sleeves are unpredictable. They can act as linear triangles or just stack up like an accordion. It is up to the artist to use them creatively, applying knowledge of shapes and tension points. Note some of the geometric forms that are found in sleeves.

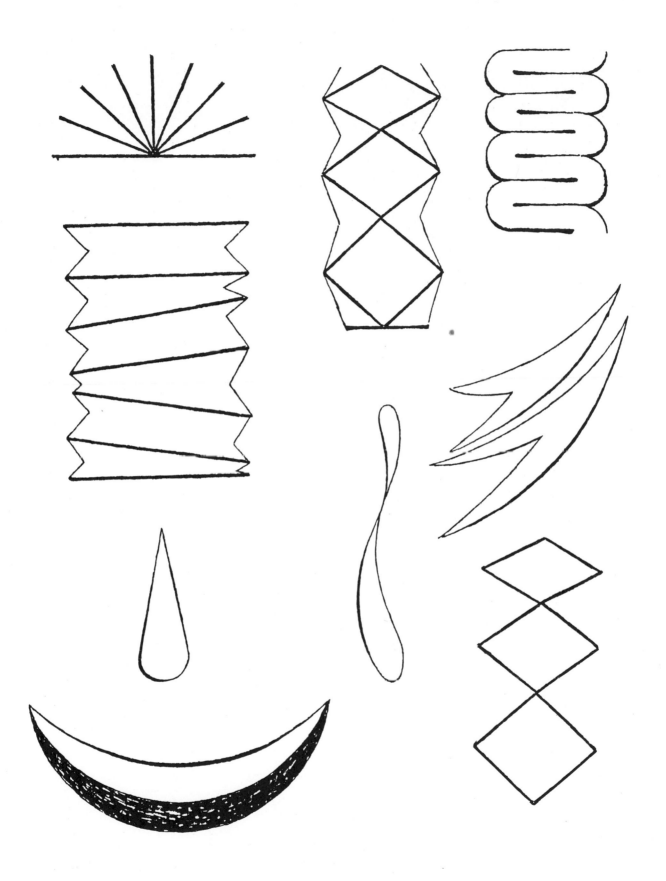

These sleeves show the telescoping type of folds usually found in heavy material such as in sweaters. Although not in tension they make interesting rhythms.

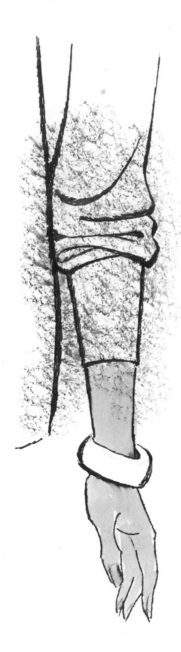
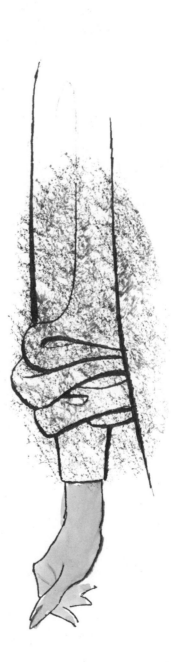

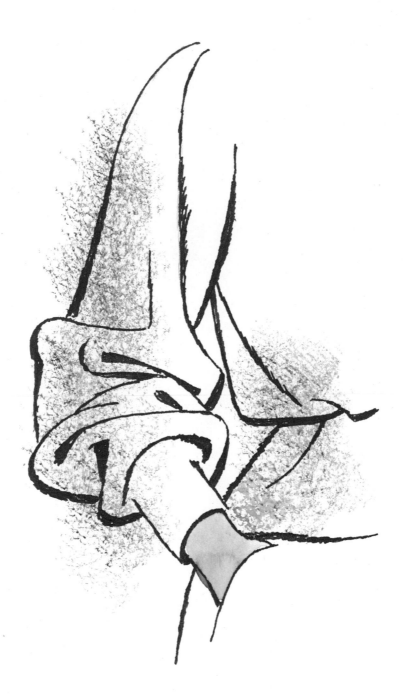

Here, an unusually heavy sweater makes twisting and constricting bel-lowslike shapes that are very interesting—but keep them under control so they don't interfere with the total design contribution of the item.

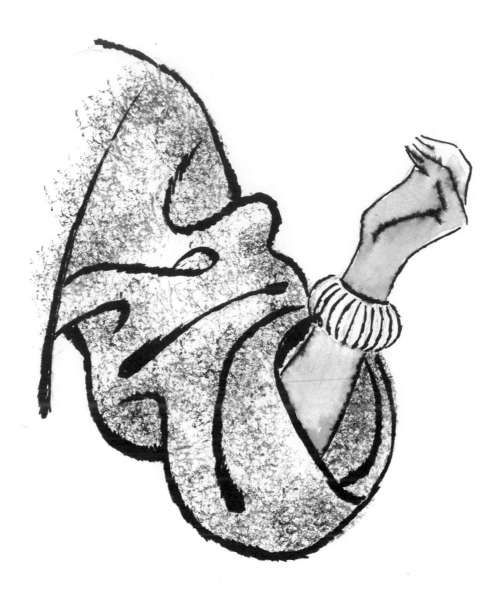

Sleeves can get completely away from tension points and be more of the bellows-stacking type, which can be very artistic and decorative and may even suggest free-form sculpture.

60

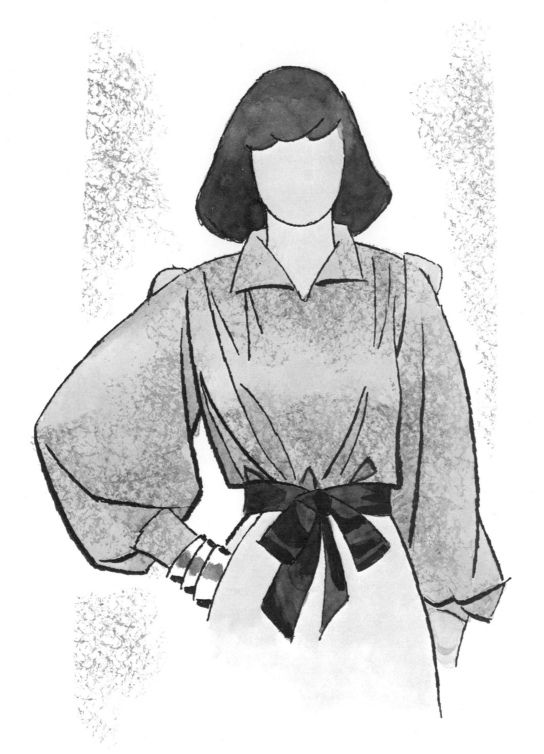

This shows a full view of a bell-type sleeve. This kind of drapery affords a wide choice of electives in design. They can be quite simple to handle once you learn the tension points.

This of course is the classical sleeve with almost every drape being a catenary. The lovely rhythm from the armpit to the wrist is a calligrapher's dream.

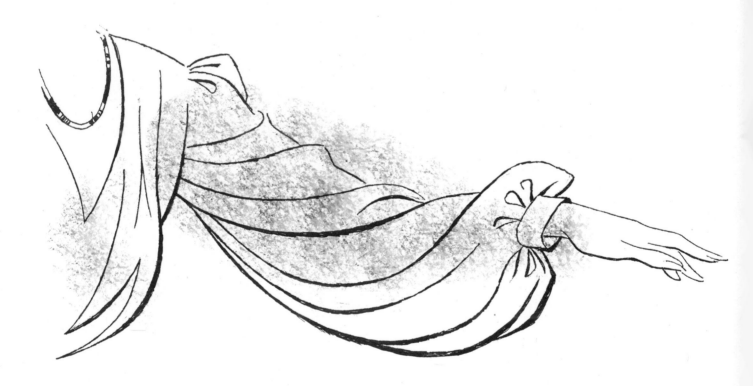

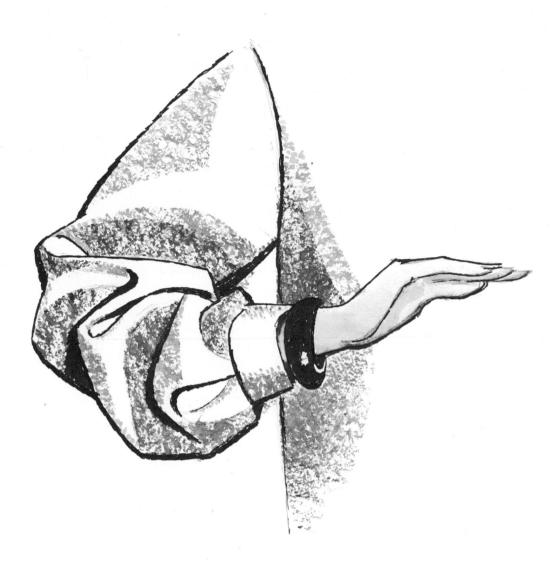

The dynamics of the loose sleeve continue in this example. The twisting and phrasing of the different elements are entirely up to you to use and when properly done can be very exciting. I have seen oil painters virtually go bananas when seeing these kinds of folds.

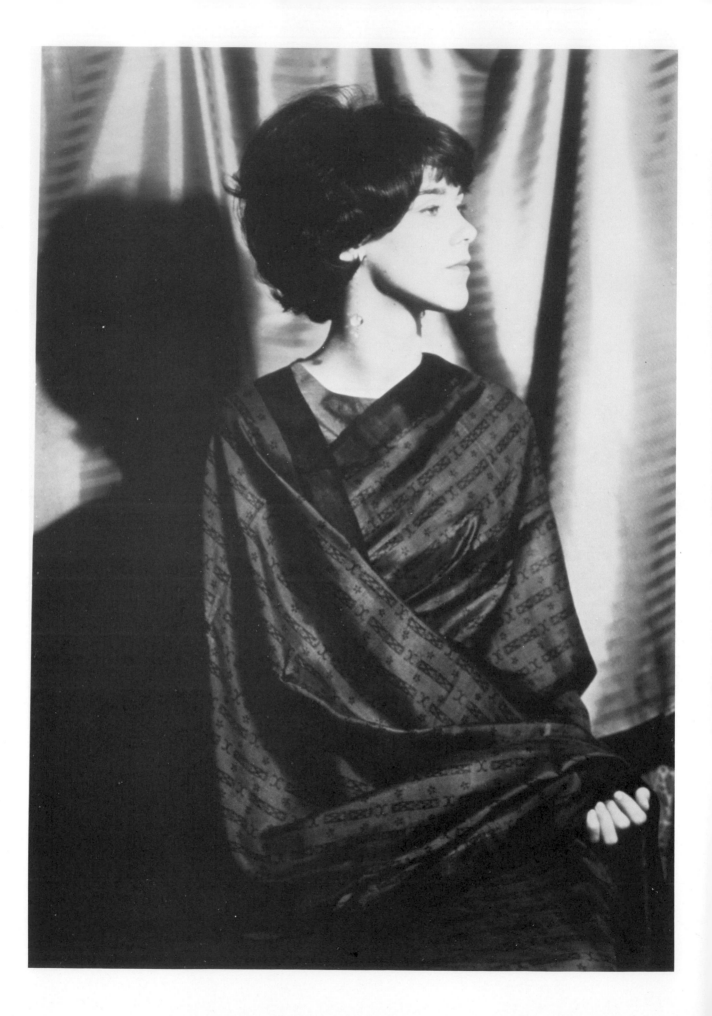

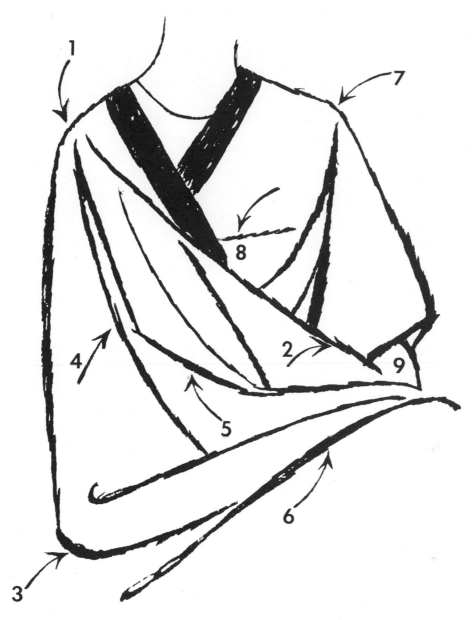

Page 64 shows a gown with drapes that are completely abstract and dynamic. The triangular patterns are analyzed above. Starting with the shoulder (1), dropping down (3), and moving along on line 6, line 2 to the shoulder makes the third side of the main equilateral triangle. Line 5 tries to make a catenary but the materials interfere with it. From the left shoulder at 7 falls the sleeve making an elongated triangle. Line 4 repeats the line on the left, 1–3, and 8 marks the edge of the "hip roof."

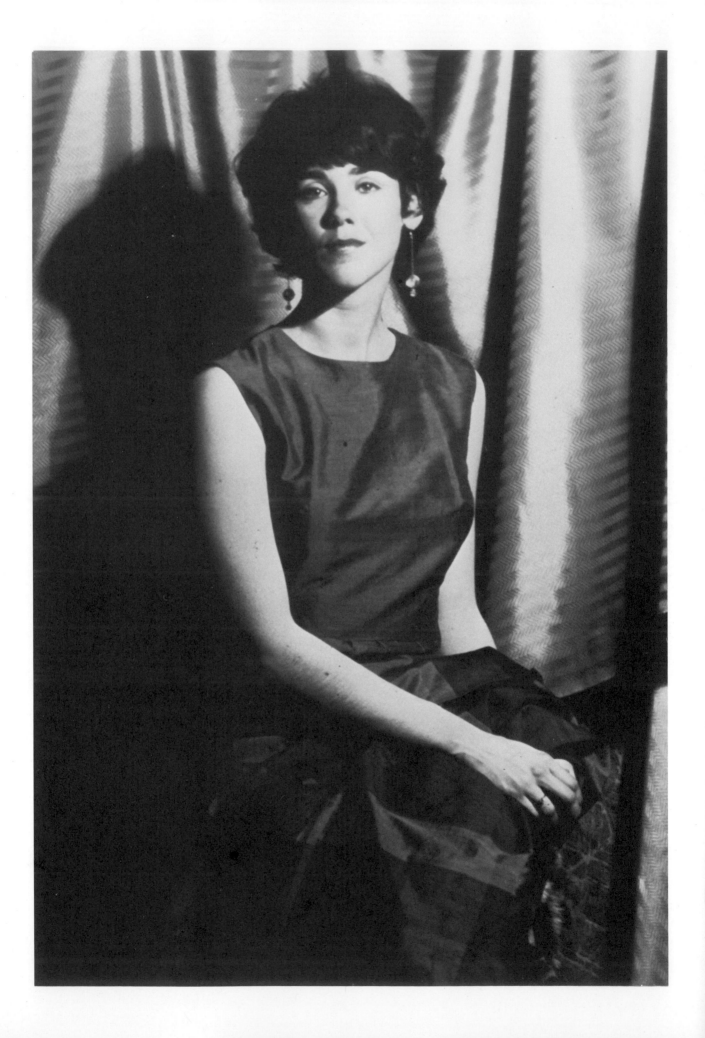

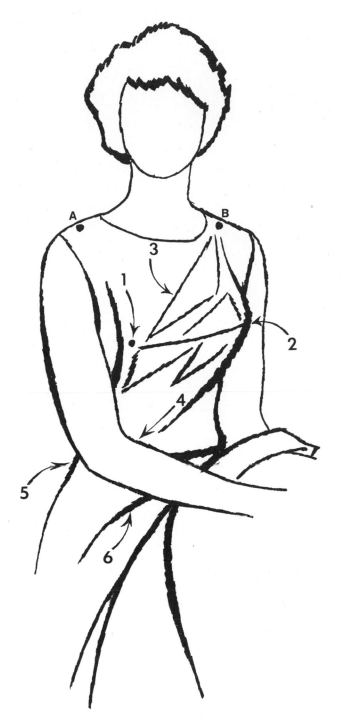

The diagram above shows tension points that can change a "hip roof" into two triangles, from shoulder B to nipple 1, to tension line 3. Note the triangle B + 1 + 2 and tension line 4 from 2 to hip 5 (also hinge line 6).

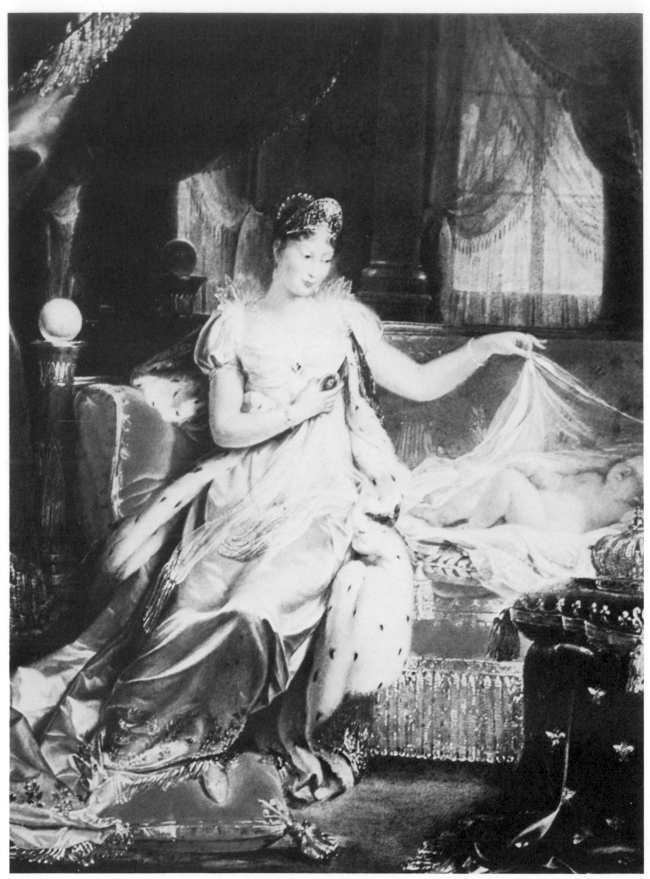

Marie-Louise and the King of Rome by Joseph Franque, Musée de Versailles.

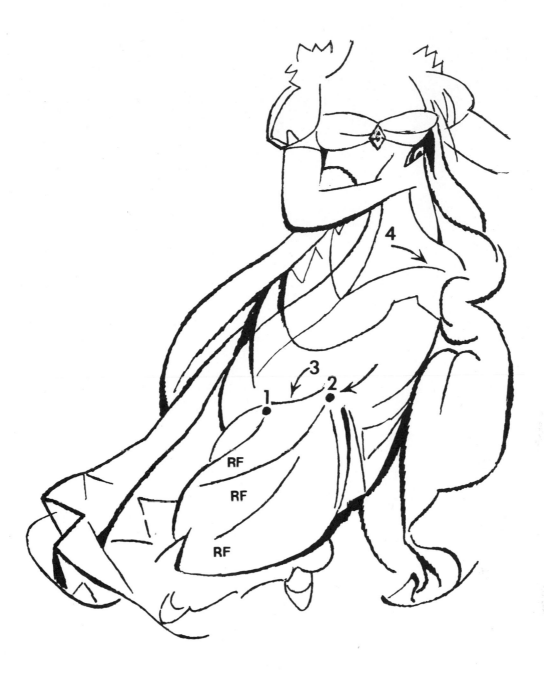

Through the years, (Empress) *Marie-Louise and the King of Rome* (her baby) has stood out as one of the most elegant portrait paintings I have ever seen. The handling of the silk textures and the reflected light is superb (see page 5). On the diagram I have marked the reflected areas with "RF." Note the catenary 3 between 1 and 2. The hinge is at 4.

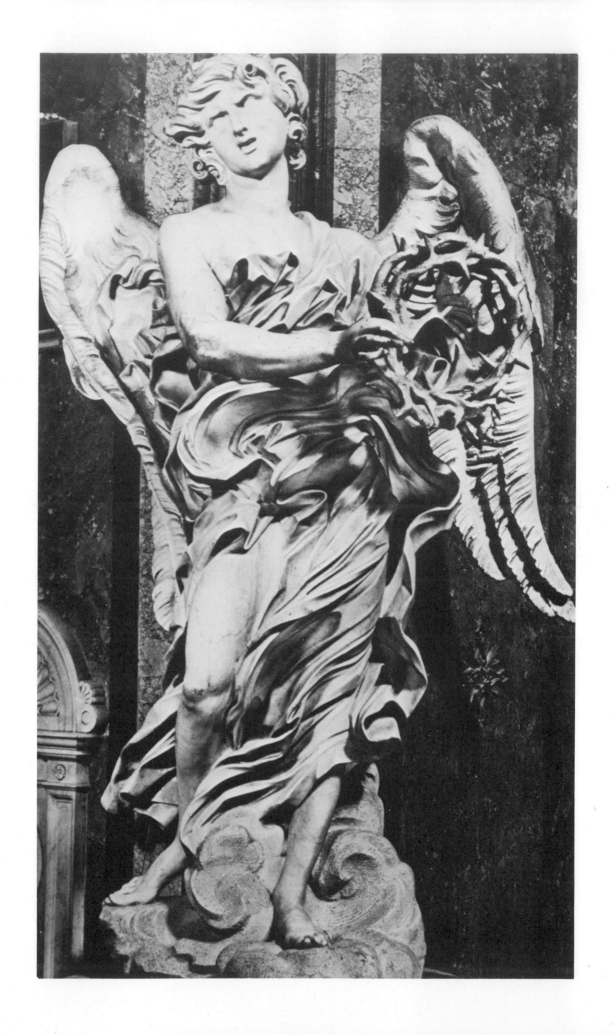

Bernini and the Oceans of Drapes

In most of Gian Lorenzo Bernini's (1598–1680) sculpture the human figure struggles to keep from drowning in a whirling sea of arabesques and triangles. The drapery, for the most part, has little regard for tension points. The drapery is a decoration of flowing lines that carry on with their own dance and now and then doing "The Boa Constrictor." *The Angel with the Crown of Thorns* is an excellent example of drapery doing its own thing.

The Angel with the Crown of Thorns by Gian Lorenzo Bernini, S. Andrea delle Fratte, Rome.

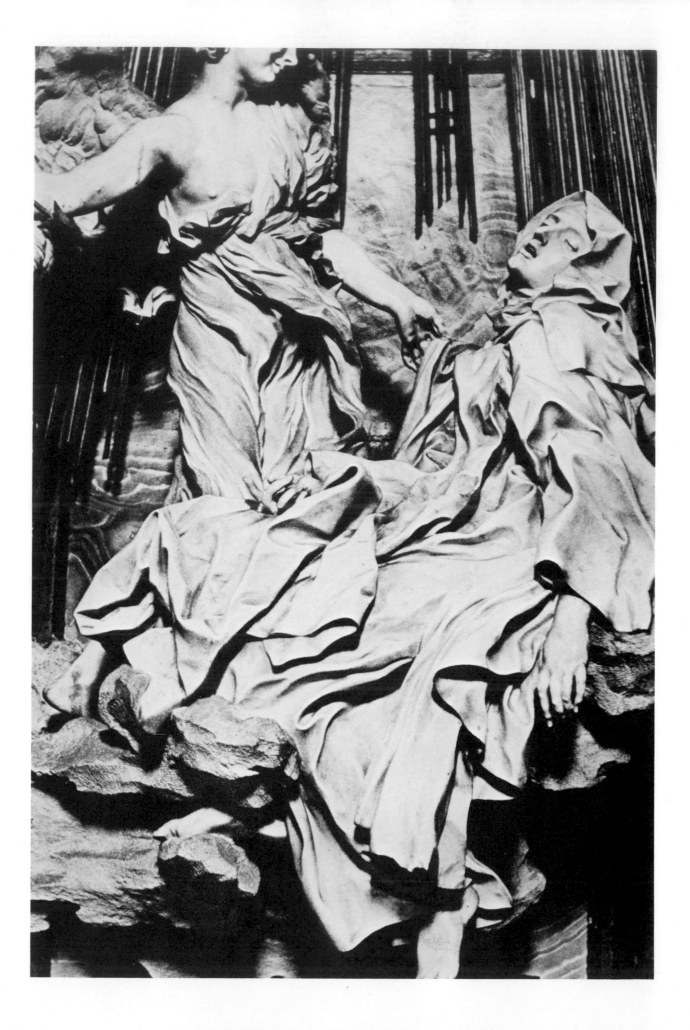

The Ecstasy of Saint Teresa is another example of drapery acting as decoration. The face, hand, and foot of Saint Teresa are like little islands in a vast ocean. Bernini had great skill in depicting the figure and seldom lost it amid the folds. Why is his work so significant? For one thing, he was a formidable figure in the sculpture of the Renaissance. In Rome one is submerged in his work. Where are the tension points of the drapery? They don't exist.

The Ecstasy of Saint Teresa by Gian Lorenzo Bernini, Cornaro Chapel, S. Maria della Vittoria, Rome.

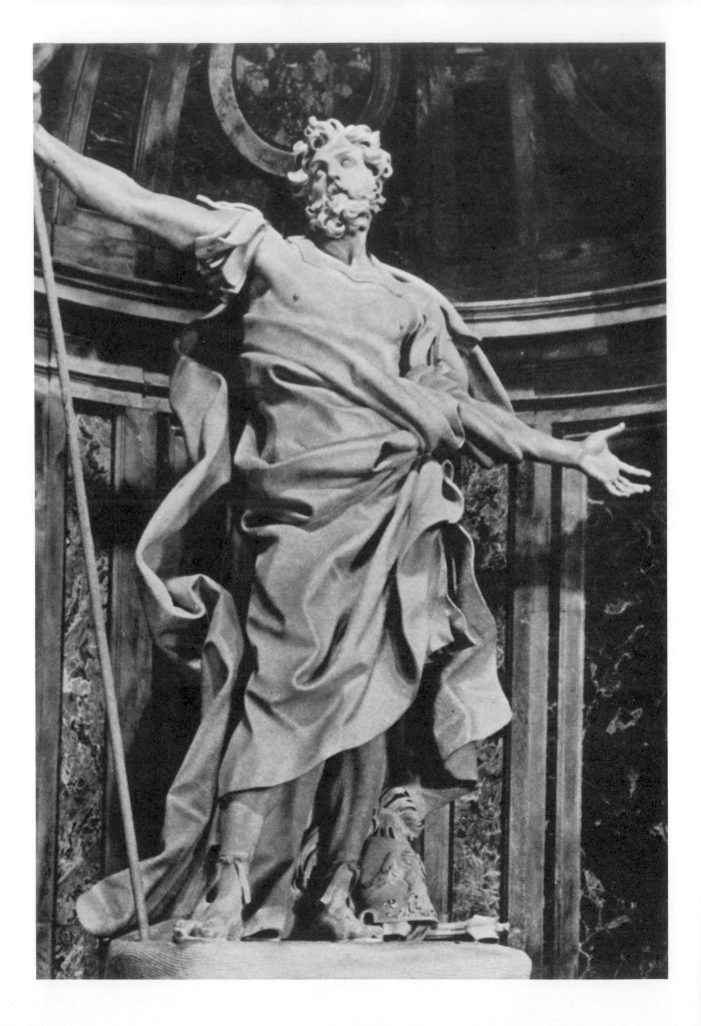

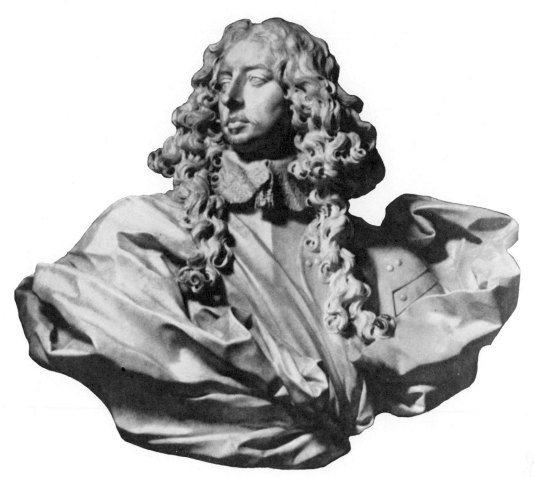

Francis I D'Este by Gian Lorenzo Bernini, Museo Estense, Modena.

This monumental sculpture of Saint Longinus, under the dome of Saint Peter's in Rome, almost has some tension points. From his hip at the left, directly under his left elbow, you can detect three radiating tension lines. One ends on the upper part of his ribs on the right side of his rib basket, the second one from the waist at left to the right hip. The last one looks like it started for the right knee and got lost. The drapery falling loose from his right shoulder goes into a zigzag boa constrictor. The drapery becomes a design like a runic mosaic of rather tempestuous rhythms and it is exciting. Besides, who is going to look for cardinal points of a compass in a storm?

The bust of Francis I D'Este is typical of the flamboyant drape sculptors used in the late Renaissance.

Saint Longinus by Gian Lorenzo Bernini, northeast pillar under the dome of Saint Peter's, Rome.

75

Following pages: *Korean Dancers* by the author (oil), Collection of the U.S. Air Force. The falling drape made triangles that were easily converted to patterns. In 1956 this costume was worn on the streets of Seoul, Korea. Now Koreans wear western jeans and these costumes can be seen only on stage.

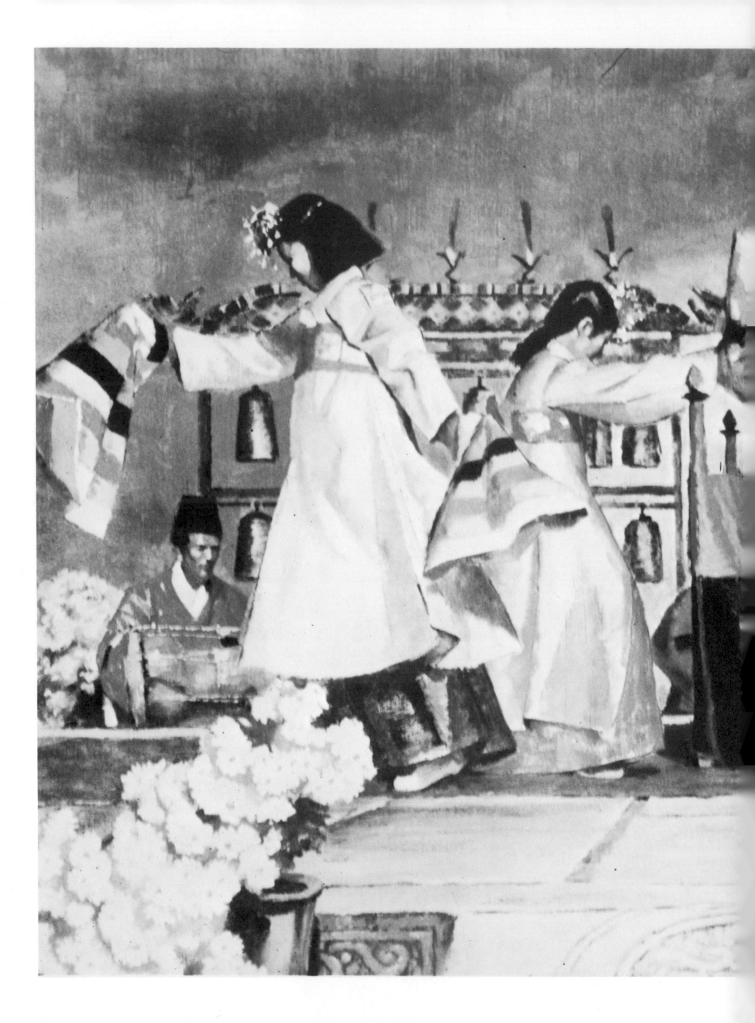

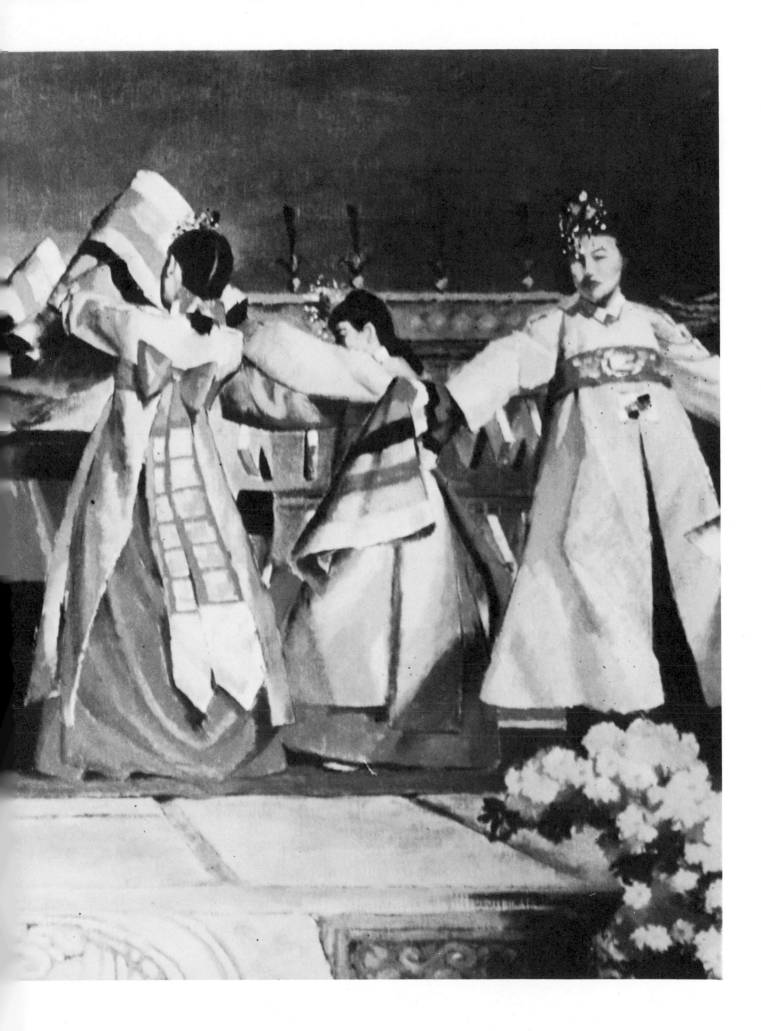

Drapery in Many Types of Art

This free-flowing gown looks quite a lot like the ones worn by the ladies at the court of Napoleon I. The only visible tension points are on the hips and the left knee. The knot between the breast tightens the material so that it molds with the outer breasts and makes the tension lines appear only in the center. The rest of the gown is suspended from under the breast.

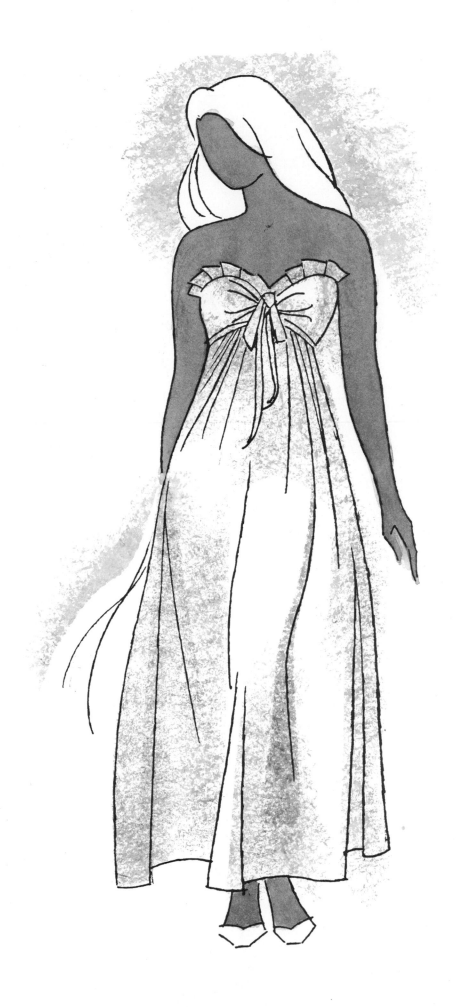

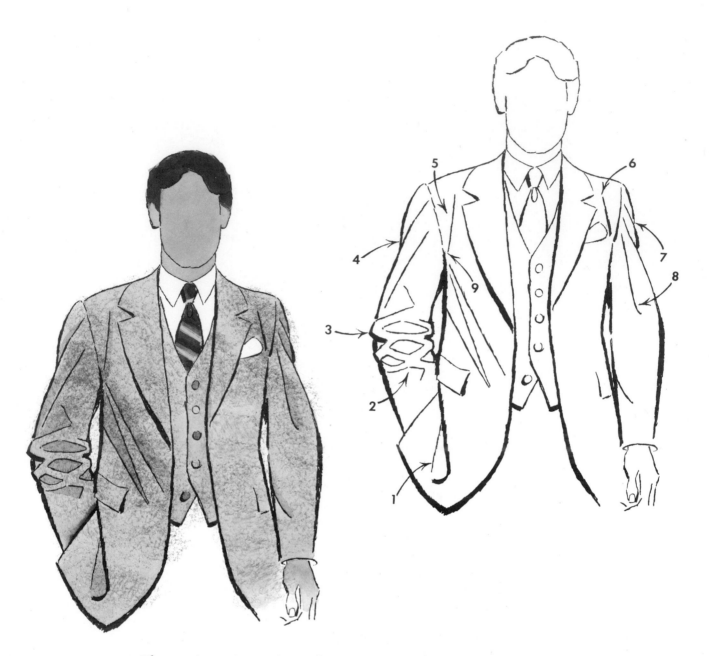

The tension points in a man's jacket are few and every fashion artist knows them by heart and uses them like shorthand. In the diagram on the left going clockwise: 1 is a loose fold making a teardrop; at 2, we have diamonds that occur in compressed areas without tension; 3 is the hinge; 4 outlines the deltoid the same as 7; 5 and 7 the inside of the shoulder muscle; 8 the half of a teardrop; and 9, the armpit.

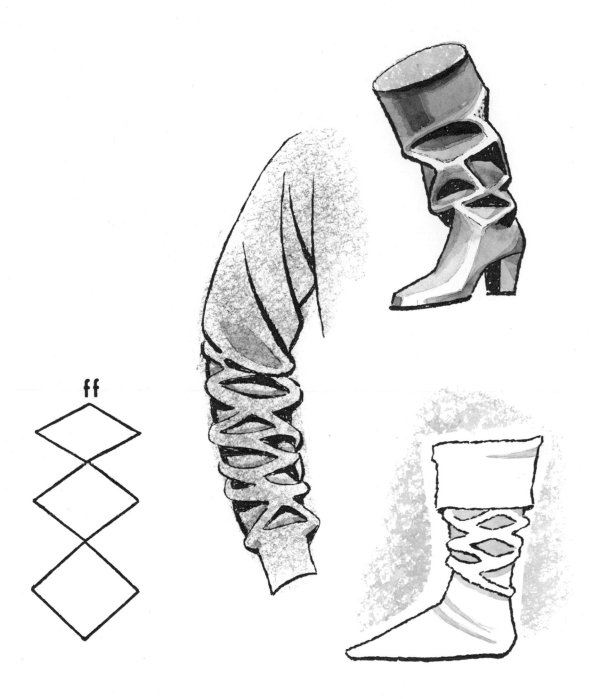

ff

This is an interesting bit of decoration that can be found in compressed areas. It happens in sleeves, boots, and anywhere else that the material has to telescope under pressure. See aa, bb, cc, and ff in the Appendix.

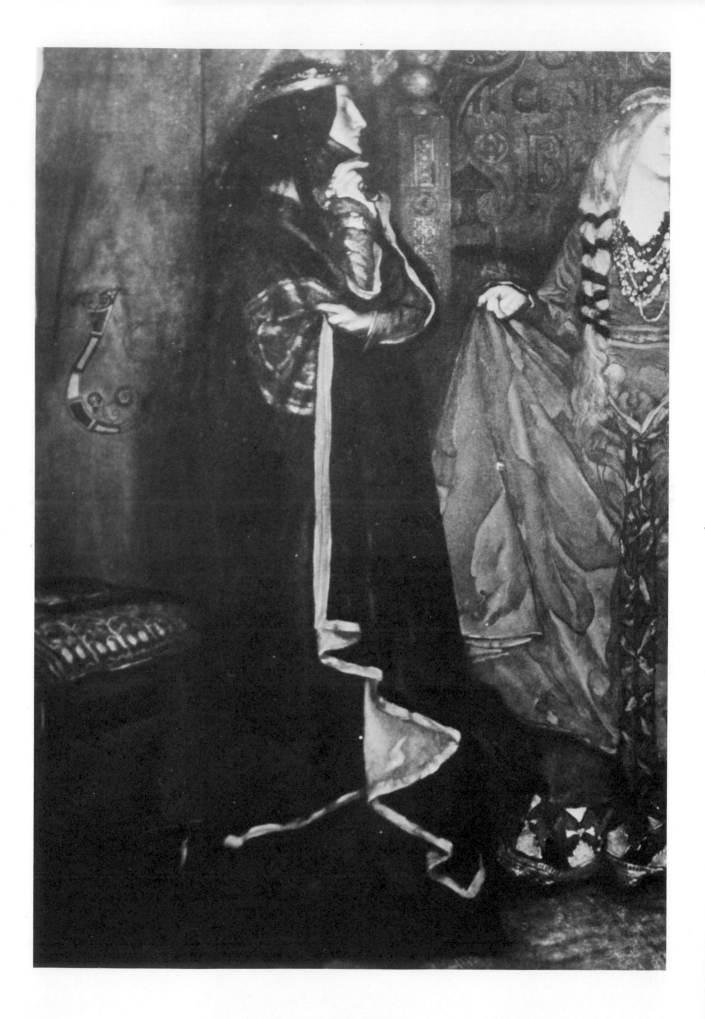

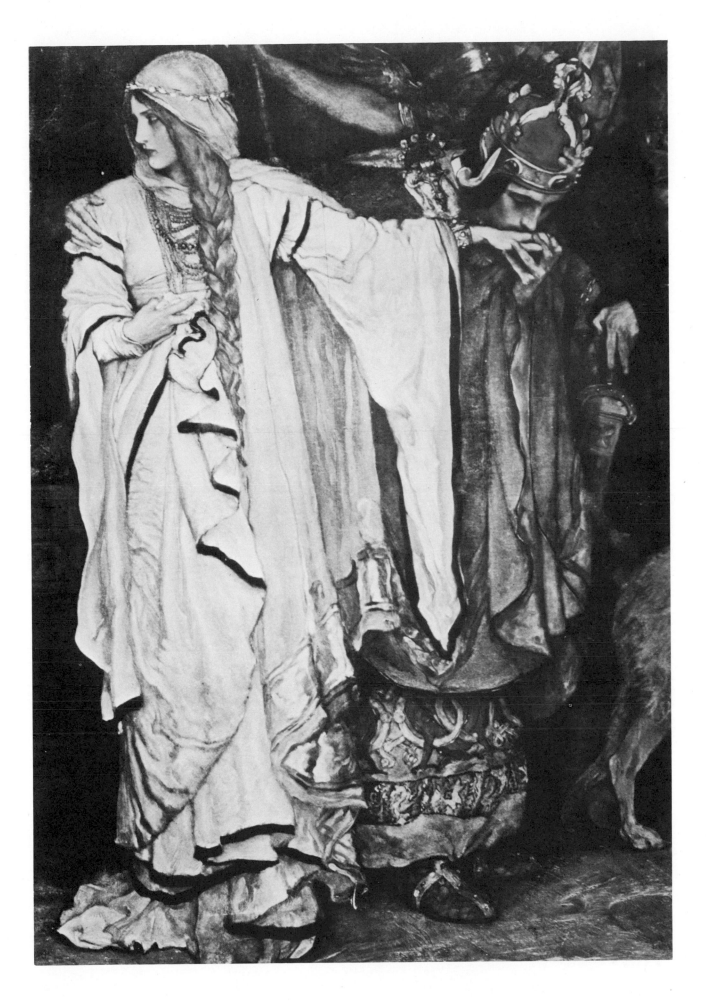

Pages 82 and 83 show sections from a painting by Edwin Austin Abbey. It was made as an illustration for Shakespeare's *King Lear*, and shows Lear's daughters. I have always admired the drapery of this painting, especially the handling of the zigzag.

On page 85, I am also including *The Baths of Caracalla* by Sir Lawrence Alma-Tadema, who was one of the great "Bon vivant" English painters of the late 1890s. Sir Lawrence had a genius for painting every incidental wrinkle that appeared in a garment, so that the costumes looked in bad need of a *repasseuse*. It was pretty much a fad of the time, and some American painters of the period did the same. You may find some tension lines in their paintings if you can survive the overgrowth of wrinkles.

Preceeding pages: *King Lear's Daughters* by Edwin Austin Abbey (painted for *Harpers Monthly* c. 1890) from the collection of the New York Metropolitan Museum.

Baths of Caracalla by Sir Lawrence Alma-Tadema, private collection.

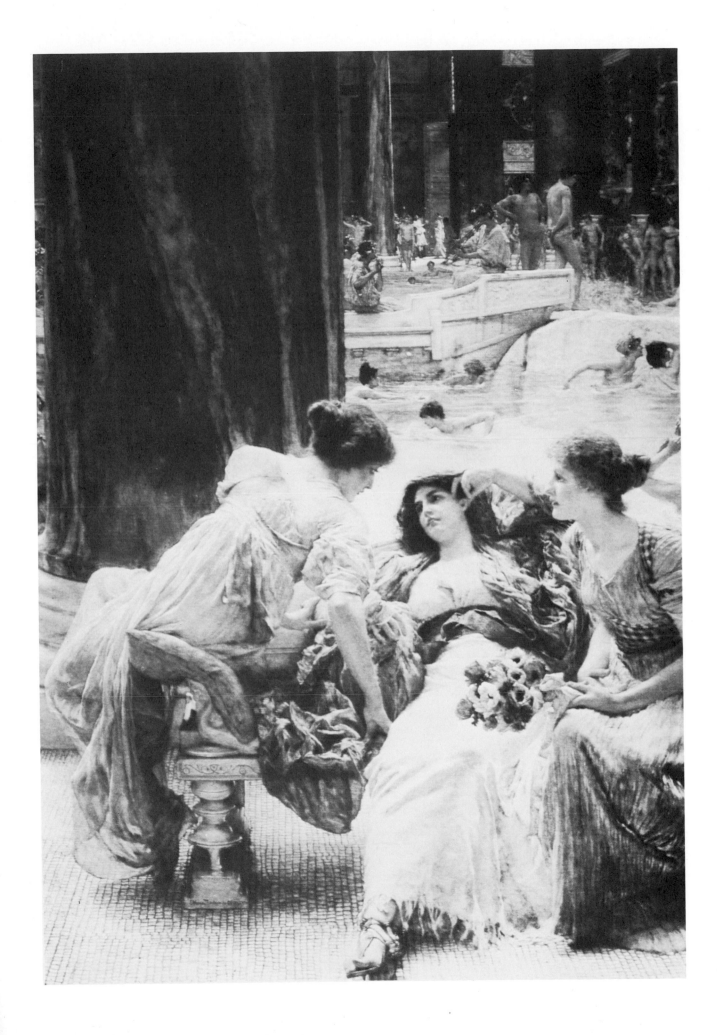

This illustration of a skirt uses symbols that we have discussed in previous chapters. Notice the V, Y, and the inverted Y, which resembles a lizard's tongue. The teardrop motif is used throughout. On the opposite page, a section of one of my illustrations shows the handling of ruffles in a large hoop skirt. When I rented this costume I took photographs of the model wearing it and it looked rather ordinary, so in the drawing I doubled the size of it, made the ribbons bigger, and generally blew it up and made it richer.

Detail of an illustration by the author, *Colliers Weekly*.

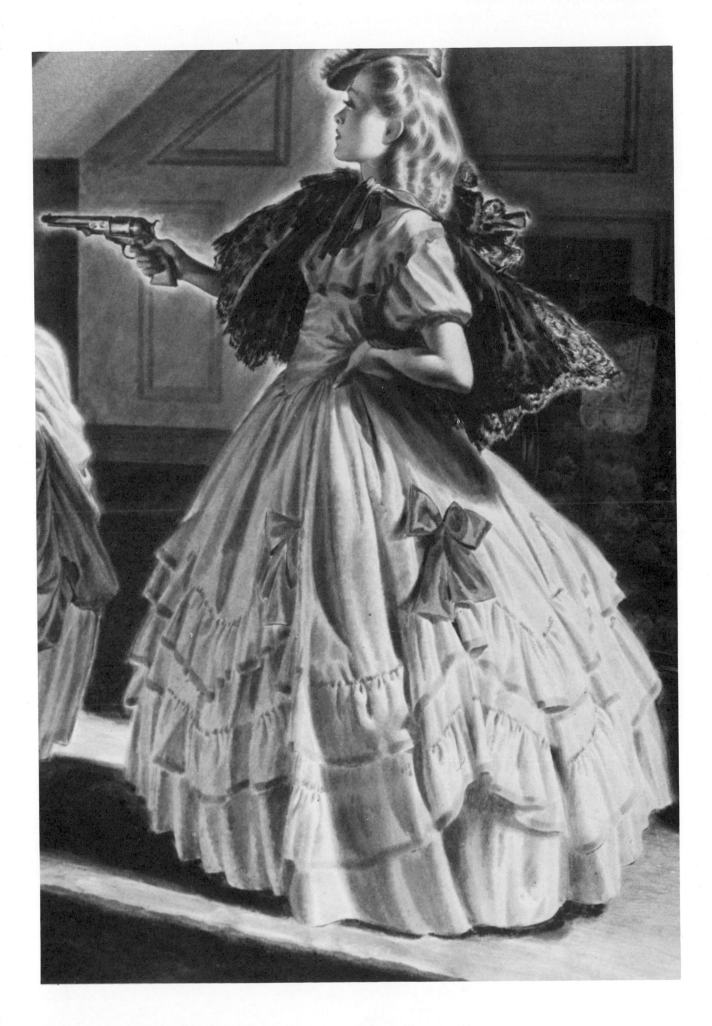

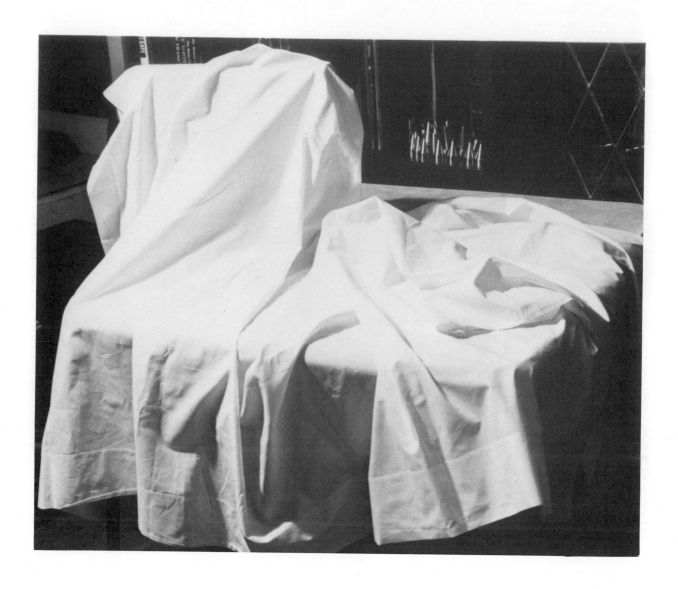

Drapery in Still Life

This drapery over a board is pretty much the way it is used in still life. It supplies ample dynamic elements like triangles, curves, and hemicones. The main object of this is to show the all-important reflected light described on page 5, and on the following page.

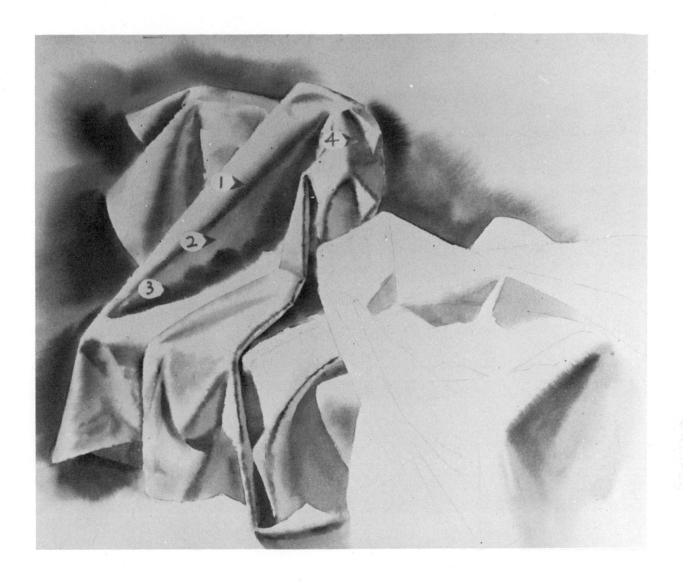

Reflected light brightens what would ordinarily be dark, almost as light as the light side. In the diagramatic sketch, 1 is the fold turning into the shadow area at 2, but the reflected light from the area to the right of 3 opens up the area at 2. While it isn't as light as the light area,* it *is* light enough to be part of the light pattern (see page 5). Number 3 is a shadow being cast by the triangular area.

*Reflected lights usually project a slightly different color than the direct light areas. This is to establish them in a different plane, so although their value is almost the same, their *color is not.*

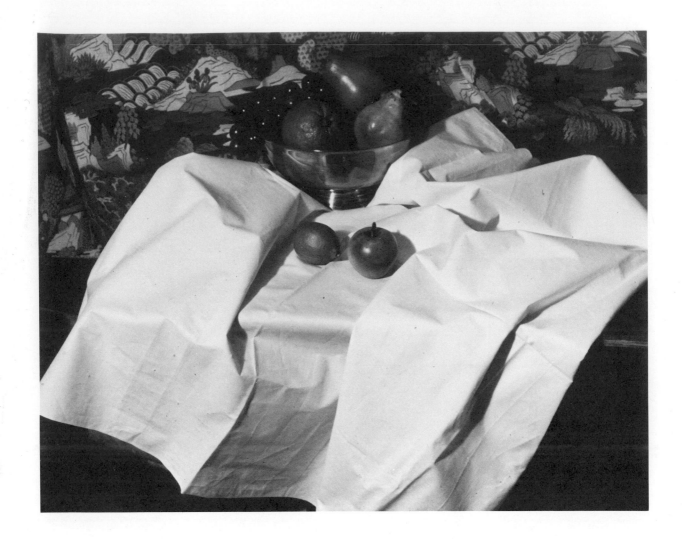

This photograph of still life with drape is interesting in that it breaks up into a number of triangular patterns. The only part of the drape that has any stress is at the edge of the table.

90

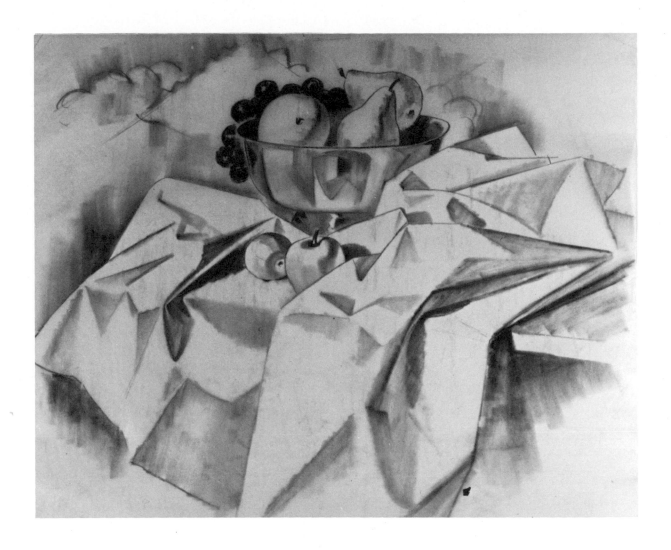

Whenever drapery is involved in a serious picture, it is always wise and prudent to make a study of it and of its dynamic gifts. The design is waiting to be absorbed and relished. I still enjoy the study I made of this set up and am glad that I photographed it.

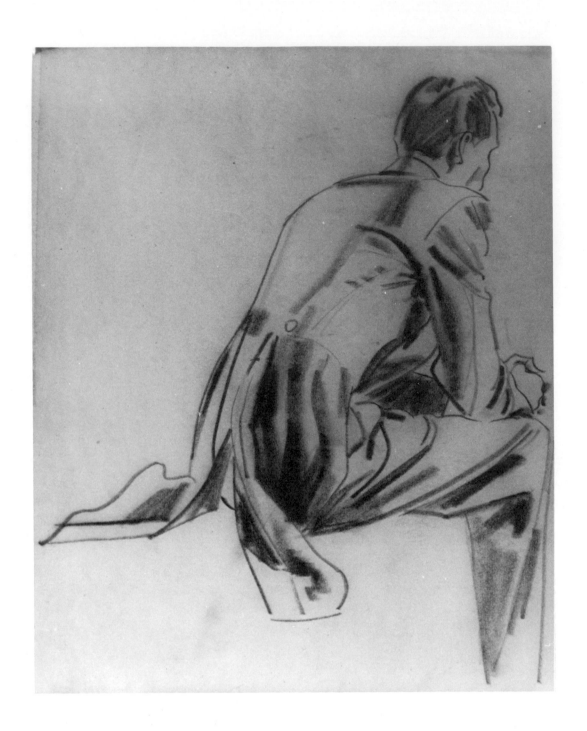

This is one of many studies that I made for many of my illustrations. I used to work out the contributing elements very carefully.

92

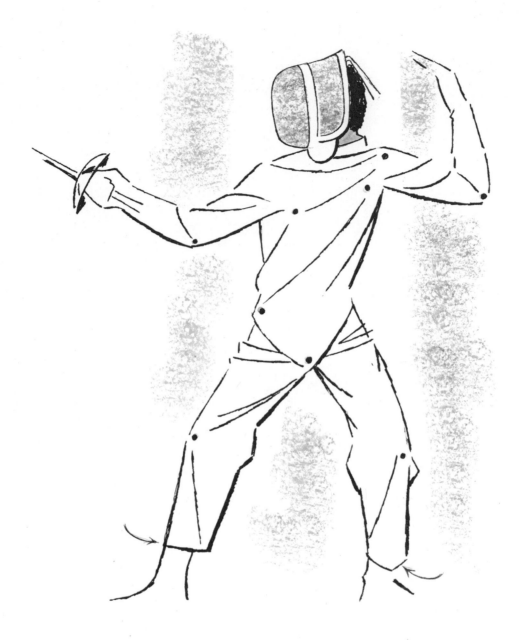

A fencing pose can be very interesting. Parsing the tension points in the diagramatic illustration, starting from left to right at the top: the elbow as the hinge, right breast with the left shoulder, left breast to the right hip, from there to the crotch where hinge lines cross from leg top to leg top and from the crotch to the knees. Note that the front of the trousers are flush with the lower part of the right leg, while the left leg has the opposite action.

Drapery in Portraits

Drapery in portraits can be very important and can sometimes make or break a painting. So it is wise to make studies of the drapery. For its transparent quality, I use tracing paper to make my studies. It is simpler to make overlay changes that you can add by taping them to the main study.

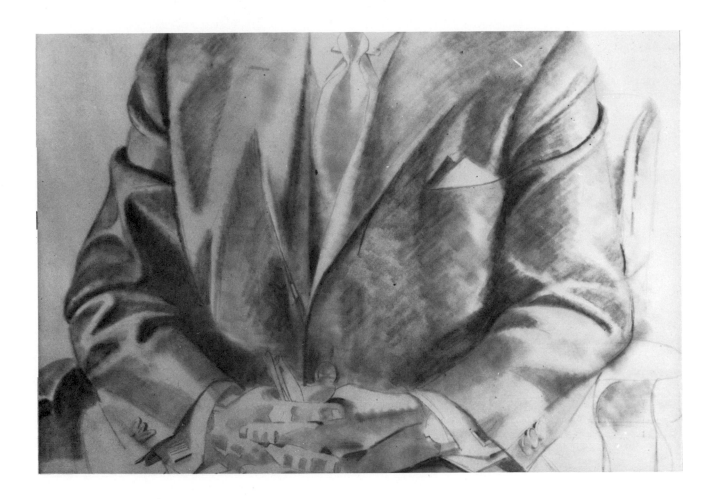

This is a pencil study on tracing paper for a portrait commission with the finished painting done in oil.

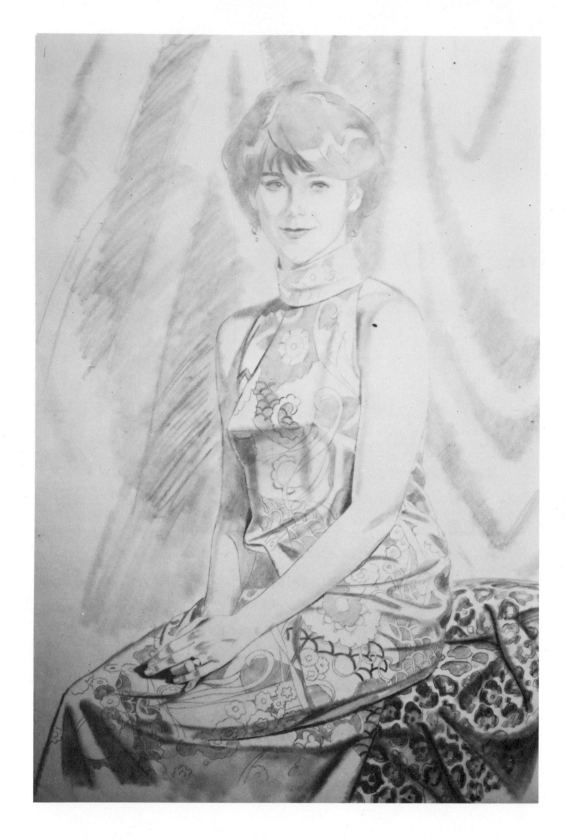

This study called for greater preparation as it had an intricate pattern that could easily get out of hand. Drapery was used in the background and that also had to be worked out.

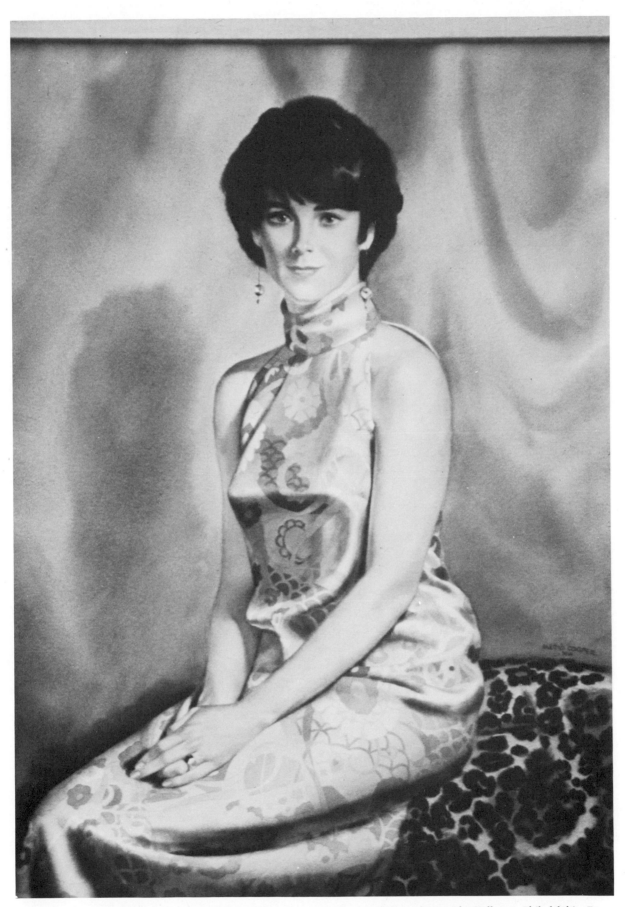

Mrs. John Hellegers (Dale, Jr.) watercolor by the author from the collection of Mr. and Mrs. John Hellegers, Philadelphia, Pa.

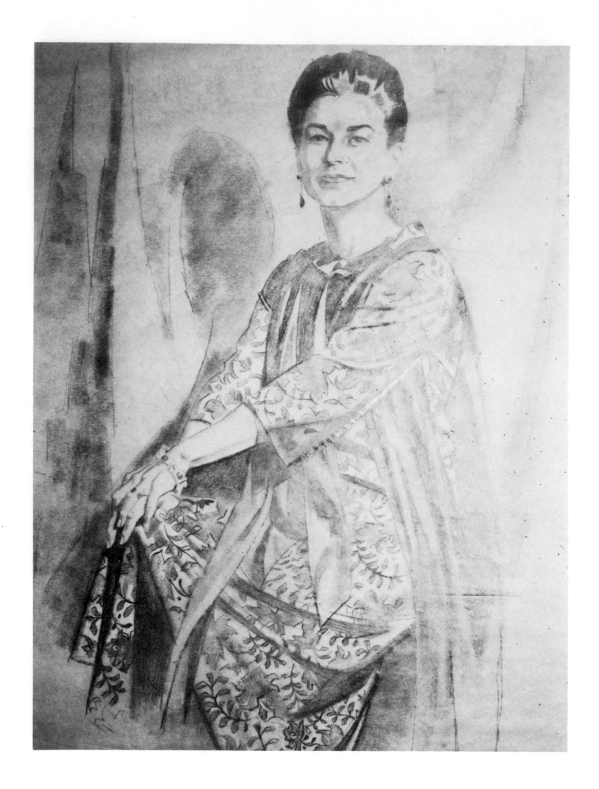

The one thing to keep in mind is not to let things get too busy. This study had a few problems. The tension lines on the left sleeve were very important. Getting somewhat of a hinge between the torso and legs was a bit of a problem as the material kept sliding, a problem encountered with some materials. However, the left knee made tension with the buttocks and radiated to the right side. This watercolor is 20 x 30 in.

Dale Meyers, N.A. by the author (watercolor) from the collection of Dale Meyers.

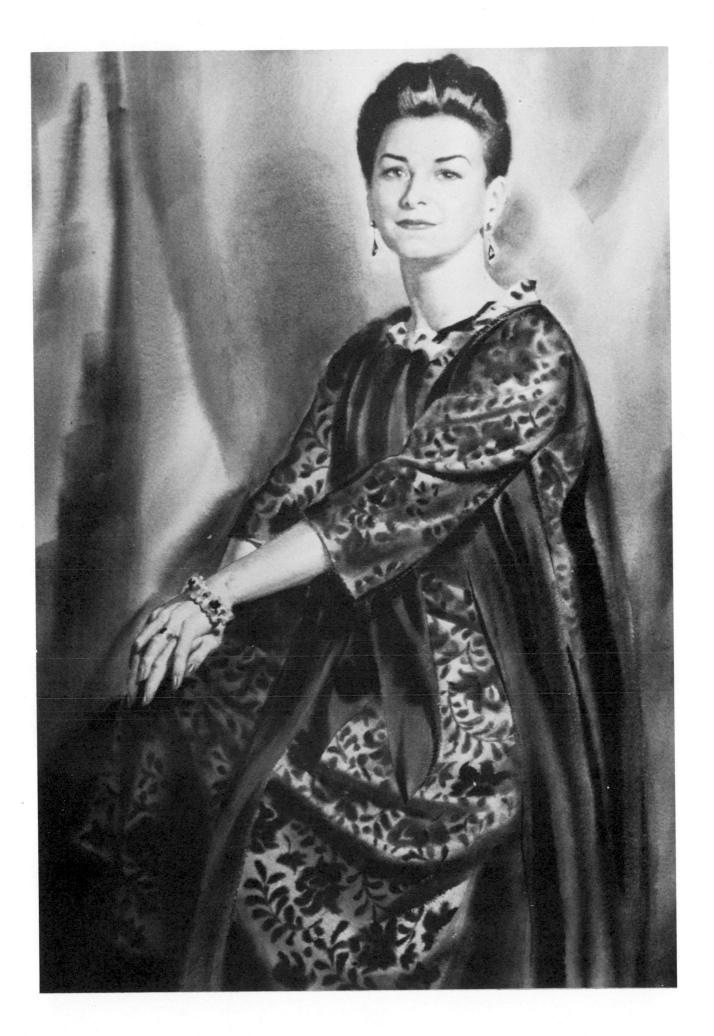

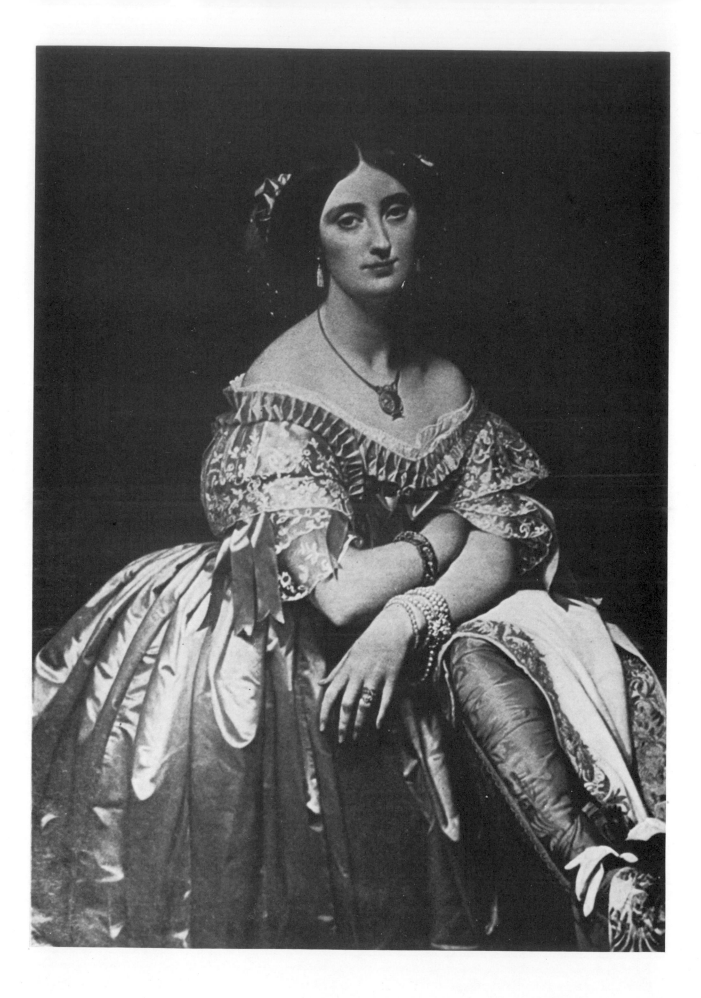

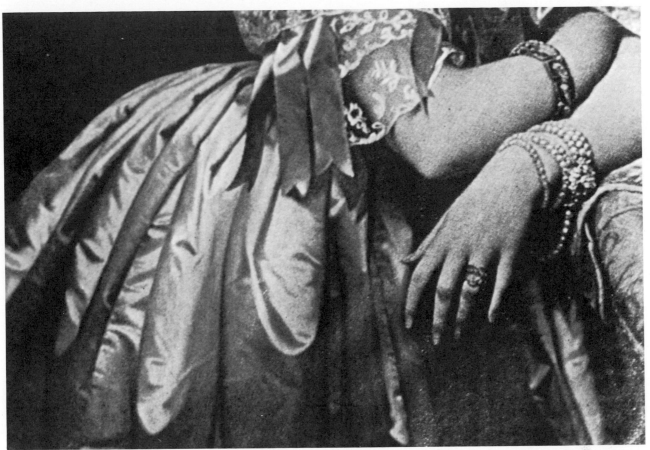

Princesse de Broglie by Jean Auguste Ingres from the collection of the New York Metropolitan Museum.

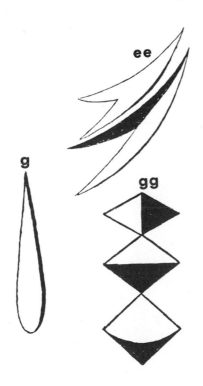

In this portrait of Princesse de Broglie, by Ingres, the huge skirt cascading over the bustle created a delightful problem for this artist who delighted in detail. As the folds poured down they allowed large teardrops to form, and the forms are filled with little hornlike shapes, similar to thorns on the stems of roses. To Ingres, who was a genius at putting small details in concert and giving the whole a great feeling of harmony—this was virtuosity! Study the smaller pattern, negative and positive, and you will find an exquisite mosaic design.

101

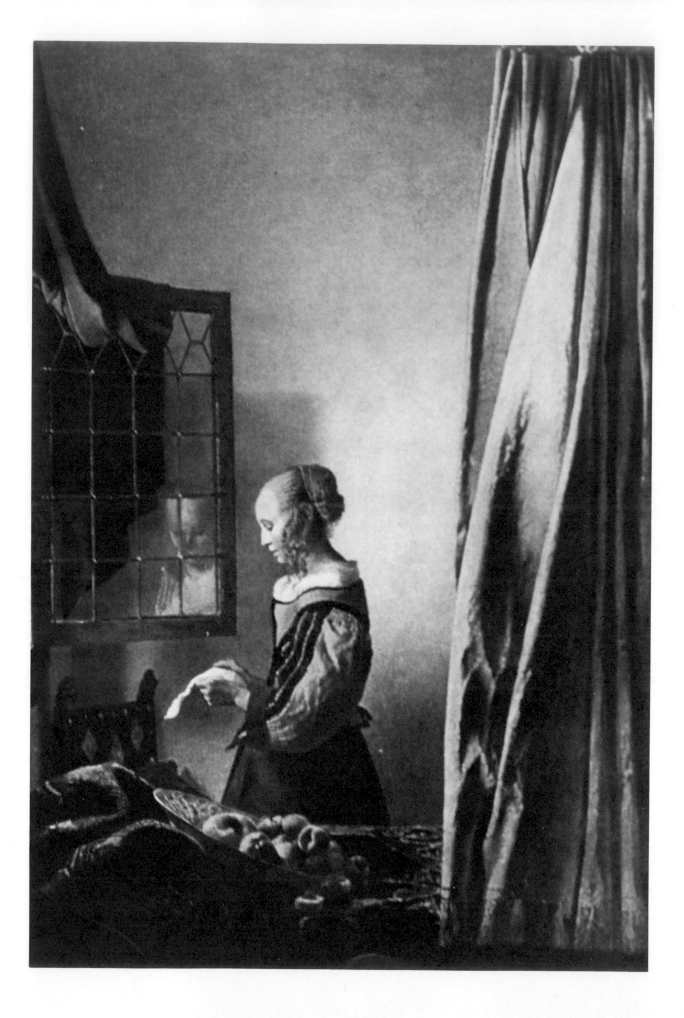

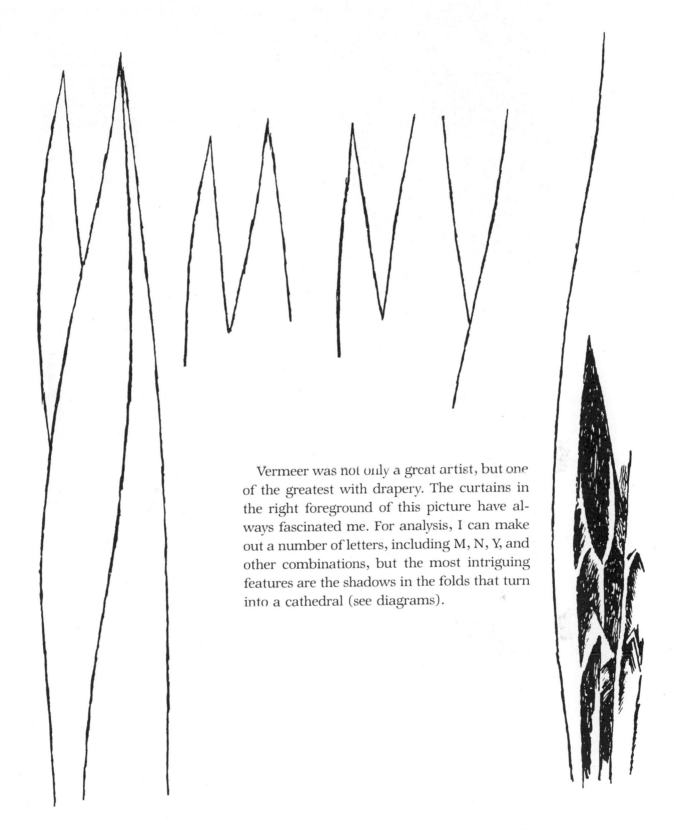

Vermeer was not only a great artist, but one of the greatest with drapery. The curtains in the right foreground of this picture have always fascinated me. For analysis, I can make out a number of letters, including M, N, Y, and other combinations, but the most intriguing features are the shadows in the folds that turn into a cathedral (see diagrams).

103

The Letter by Jan Vermeer Van Delft from a 1912 German print, Die Galerien Europas, Staatsgalerie, Dresden.

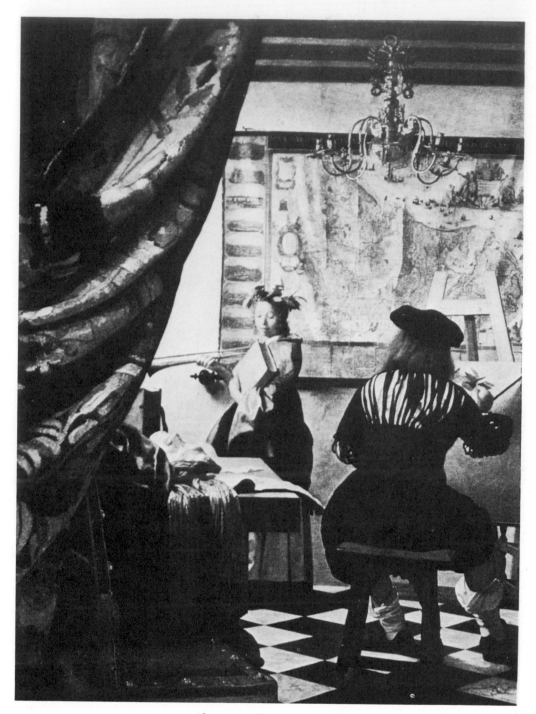

The Artist in his Studio by Jan Vermeer (1632–1675), Vienna Collection.

The drape on the left of this picture forms a slanting straight line made up of the ends of six catenaries. At the top left, an italic *D* can be made out. On the map hung on the wall you can see catenaries starting just beyond the chandelier, continuing all along the top of the map, and running out at the bottom just beyond the artist's left shoulder.

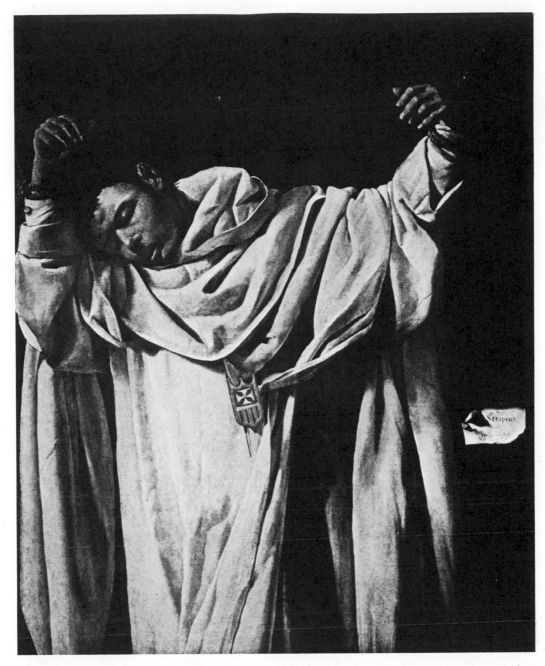

Saint Serapion by Francisco de Zurbaran (1628), Wadsworth Atheneum, Hartford, Ct.

This is a very popular painting in a number of art history books. The number of folds in the picture is impressive. However, it does not have the selectivity of an Ingres or Vermeer. The drapery is casual and does not insist on the precise rhythms of Ingres—it is relatively unstructured. The reflected light is beautifully handled and well worth the study.

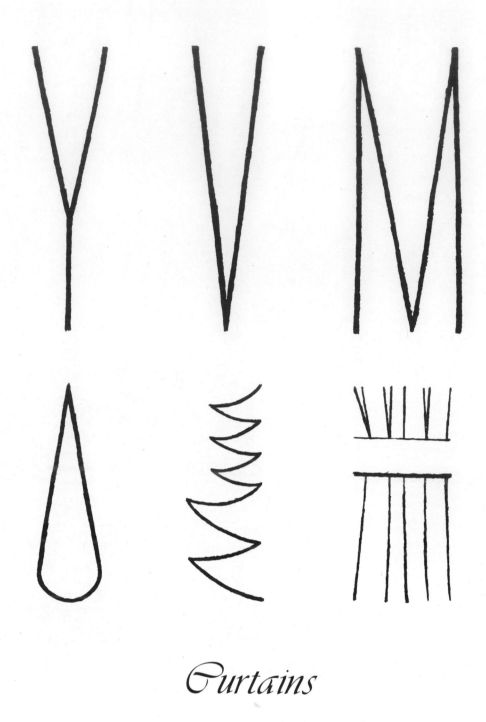

Curtains

If we keep in mind just a few letters, we can generally apply them to most drapes. The following patterns from the Appendix can be seen in the curtain on the opposite page: b, c, d, f, g, and i.

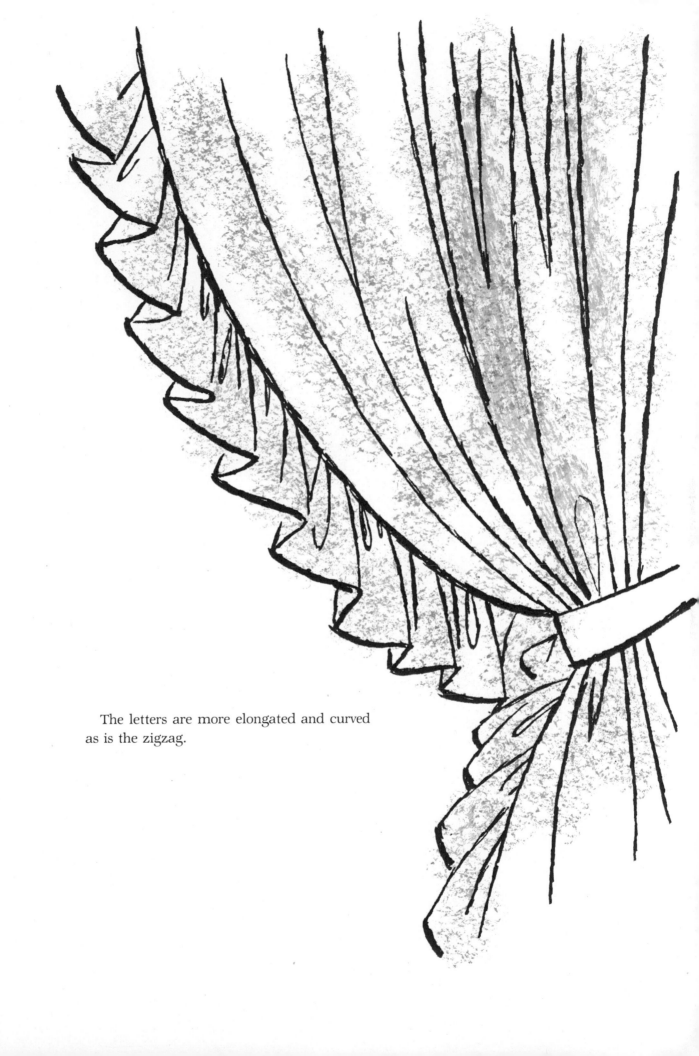

The letters are more elongated and curved
as is the zigzag.

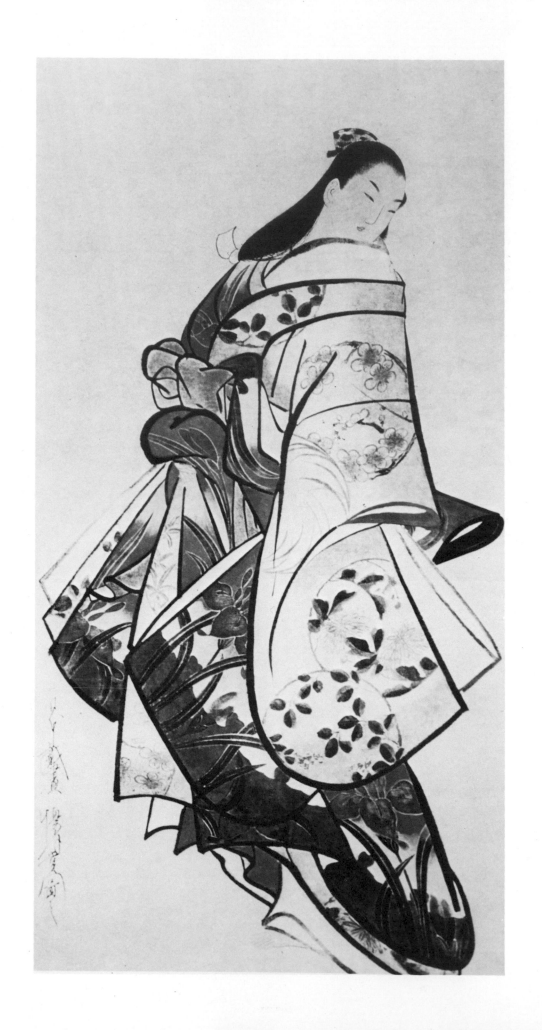

Japanese Influences on Drapery

The Japanese used lines like poetry: sometimes lyrical, sometimes dramatic. In depicting an old man, beggar, drunk, or ghost, their lines became ragged and torn. When depicting a Samurai, their lines turned into slashes of the sword! But when illustrating or painting a Lady of Court, the lines became rhythmic, rich, and lyrical.

Japanese Courtesan by Kaigetsudo Ando, Edo period, Ukiyoe school (early eighteenth century, ink and color on paper). Freer Gallery, Washington, D.C.

109

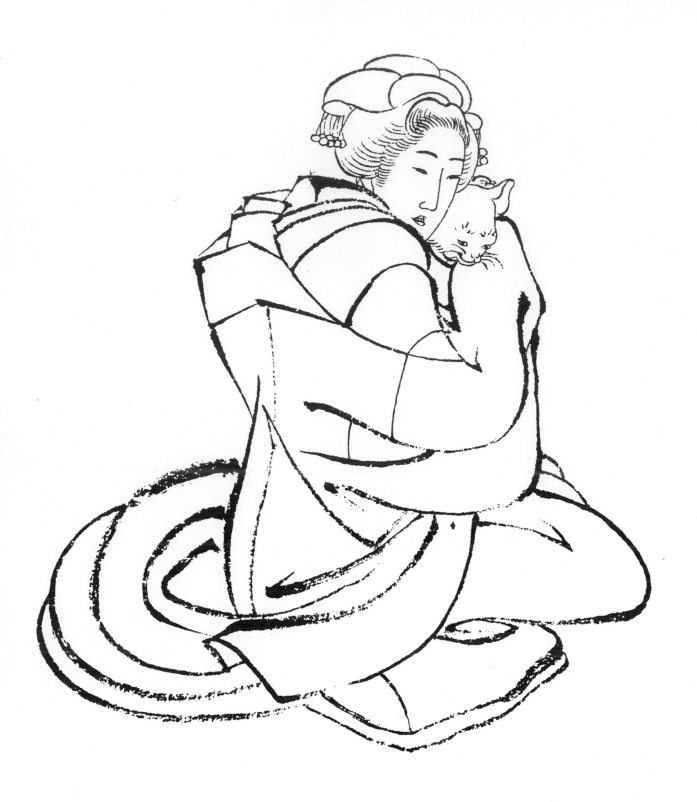

Girl with Cat by Hokusai. Freer Gallery, Washington, D.C.

110

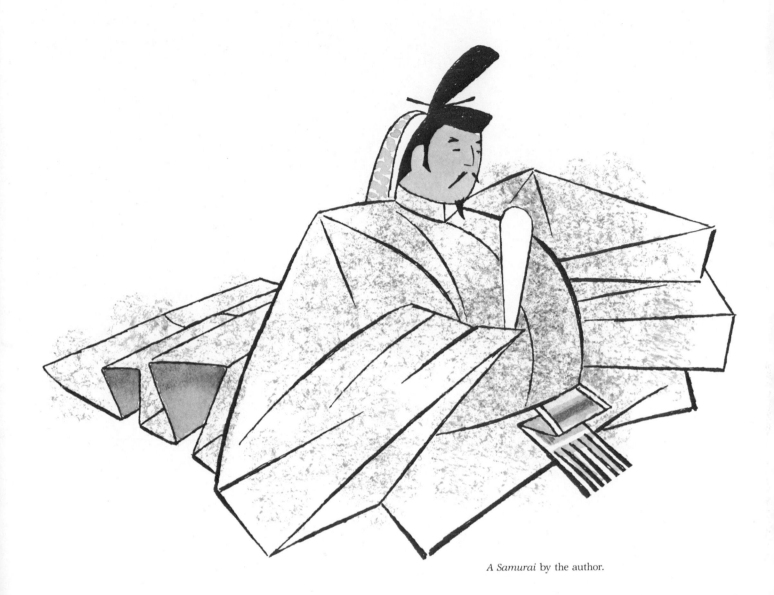

A Samurai by the author.

111

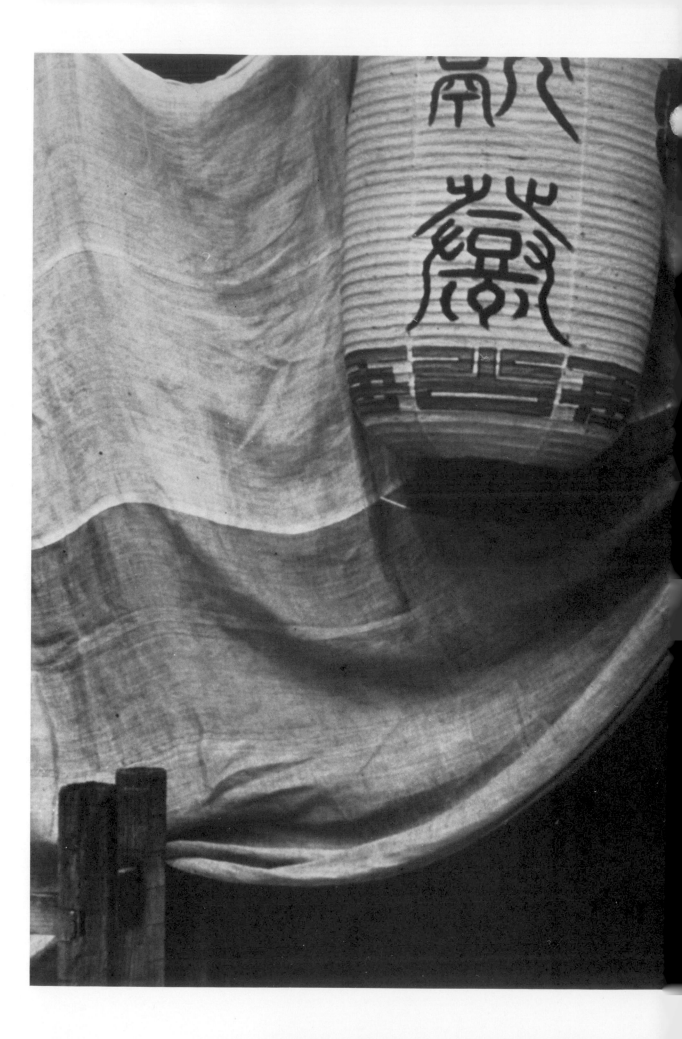

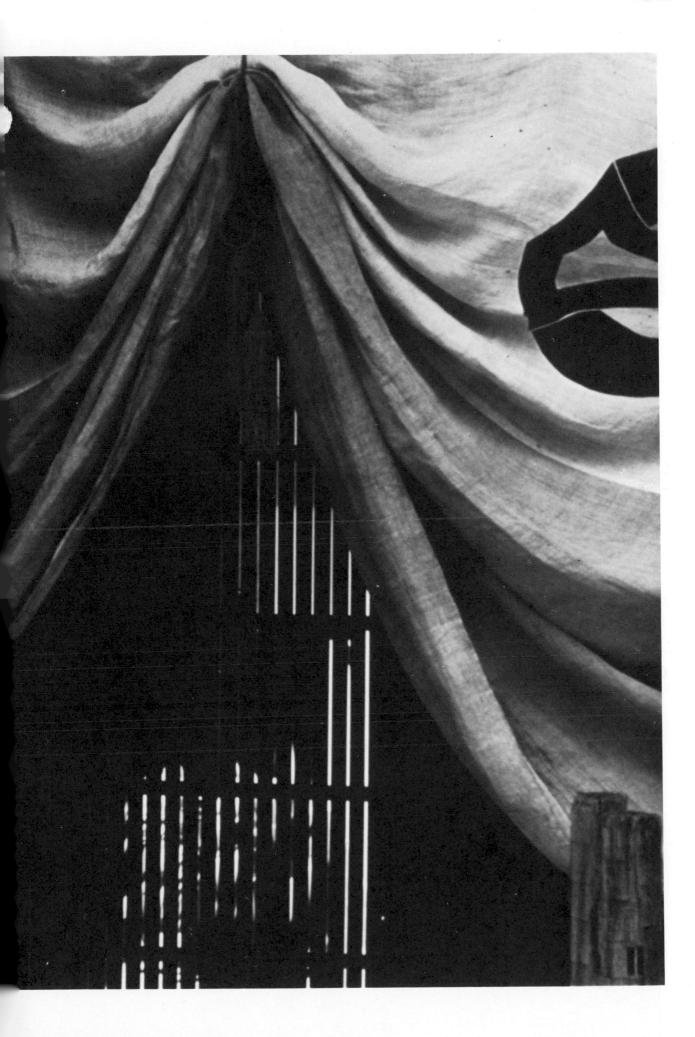

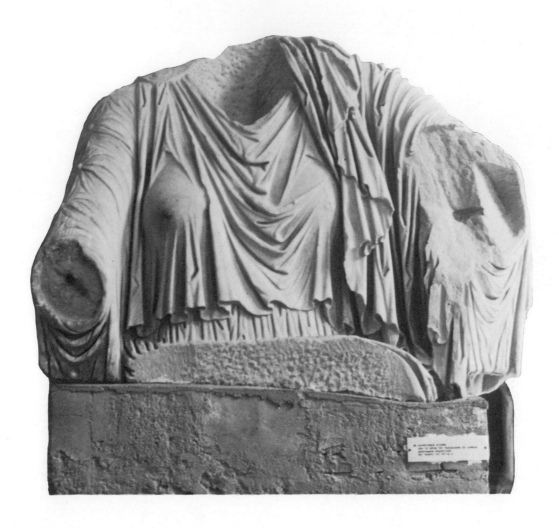

Bust in the Acropolis Museum, Athens.
Photograph by the author. This picture has
everything in it that I have written about
and shown in this book.

Preceding pages: *Coffee House in Pontocho.*
Photograph by the author.

114

Appendix

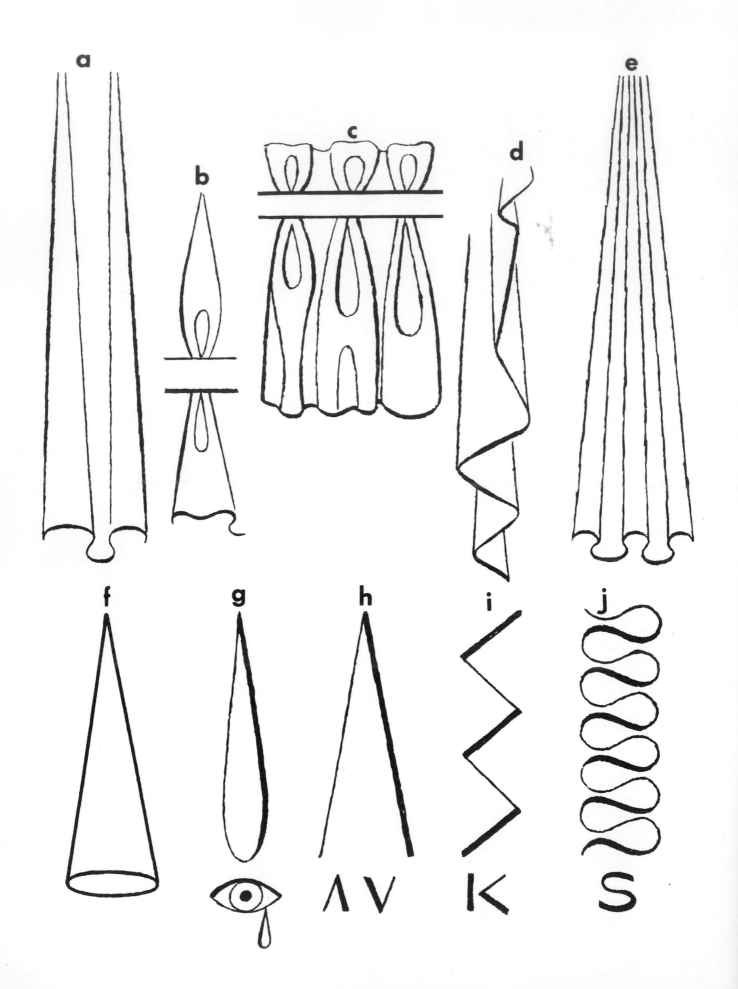

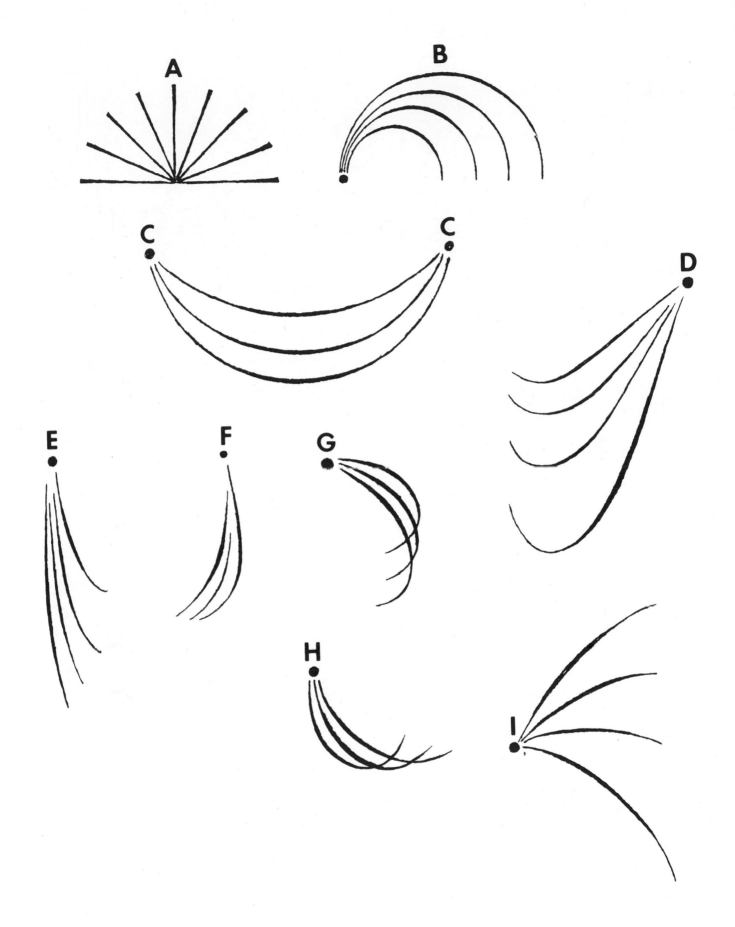

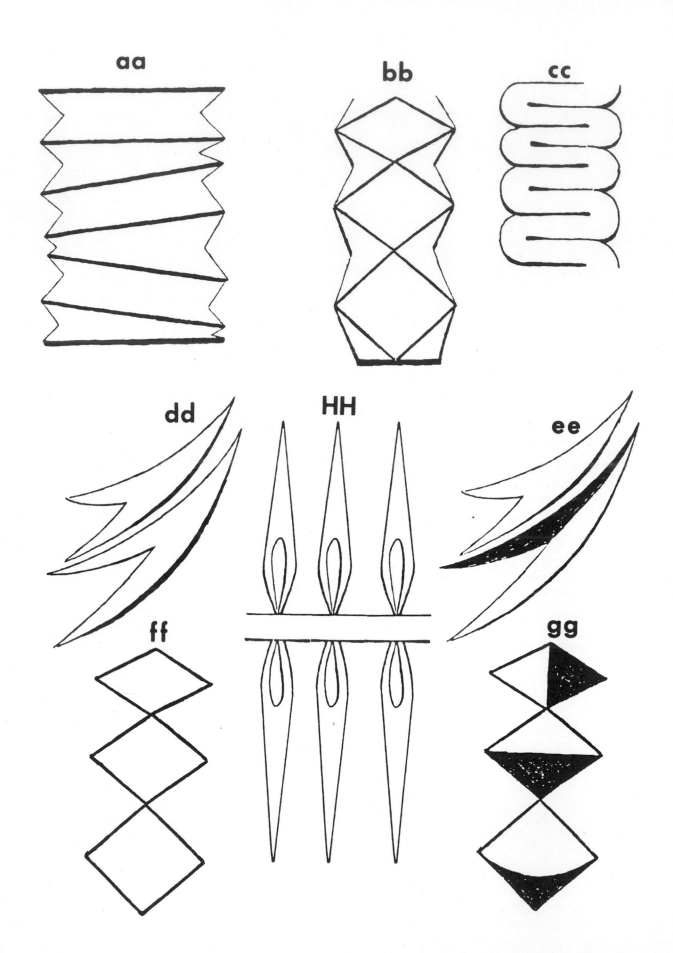

Index